Images of America
GARLAND

ON THE COVER: This is a view of Main Street in Garland, also a part of the National Bankhead Highway. Roy Rogers visited the city in 1937 with the premier of his first movie. (Courtesy of Landmark Historical Society.)

IMAGES of America
GARLAND

Paul Himmelreich

Copyright © 2014 by Paul Himmelreich
ISBN 978-1-4671-3226-8

Published by Arcadia Publishing
Charleston, South Carolina

Printed in the United States of America

Library of Congress Control Number: 2014933921

For all general information, please contact Arcadia Publishing:
Telephone 843-853-2070
Fax 843-853-0044
E-mail sales@arcadiapublishing.com
For customer service and orders:
Toll-Free 1-888-313-2665

Visit us on the Internet at www.arcadiapublishing.com

To my family for their encouragement. My beloved wife, Mary, and daughter Patricia Shaw and her family for their enduring love. I especially appreciate the editorial assistance given by my daughter Annette Himmelreich.

Contents

Acknowledgments		6
Introduction		7
1.	Becoming Garland	9
2.	Rural Roots and Community Growth	27
3.	Postwar Industrialization and Suburbia	53
4.	Boom and Expansion	75
5.	Preserving Our Past, Finding Our Future	99
Mayors of Garland		127

Acknowledgments

I am indebted to the office of Mayor Doug Athas and his able assistant, Elizabeth Dattomo, who opened their resources for my research. Special thanks to city secretary Lisa Palomba, who gave me access to city archival records. Additionally, I appreciate the help of Joe Harn of the Garland Police, Elizabeth Kimbrough of Garland Power & Light (GP&L), and Paul Henley and Merrill Balanciere of the Garland Fire Department.

I also appreciate the casual conversations with working local historians Richard Abshire, Jim Gatewood, Jerry Flook, and Sue Watkins. Additionally, much thanks for the opportunities to gather answers to a variety of questions from longtime Garland locals Tiny Huffaker and Cecil Williams. The Williams collection of Garland photographs was particularly helpful. I am thankful for contributions from Mike Hayslip and the Landmark Historical Society for publicly released photographs they allowed me to share again. A number of local citizens have opened their homes and minds to allow my inquiries and photograph replications, including Eric Deasin of KRLD-Radio; Irma Heckard; the Carver Alumni Association, who is working on its own history; Darlene Summerfelt; Shannon Fears of First Baptist; Lana King of First at Firewheel; Clifton Tucker; Charlie and Amy Thibodeaux; Carlos and Jennifer Acosta; Billie Nicholson; Ray Markell; the Barnetts; Joy James; Randy Hale; Mrs. Estes of Garland High School; Ruth Buchholz; and a number of great Garland citizens I have done business with for 40 years. I am especially thankful for my computer guru, Shanandoah Zetos, as well as the patient support of my editor, Ginny Rasmussen, and publisher, Jeff Ruetsche. All images appear courtesy of the Garland Landmark Historical Society and the Williams collection unless otherwise noted.

Introduction

Garland is the product of a merger of the pioneer settlements of Duck Creek and Embree, both railroad towns. Originally, an old Duck Creek community formed in this farming region of northeast Dallas County in 1874. A Mr. Moles built a corn mill and store on the west bank of Duck Creek. A cotton gin and other businesses were added through the 1860s. Many were started by settlers of Peter's Colony.

By 1886, both the Santa Fe Railroad and the Missouri-Kansas-Texas ("Katy") Railroad had built trackage through the area. Both lines bypassed old Duck Creek and established separate depots around two new communities. The new Duck Creek ran to the north with the Katy and Embree along the south with the Santa Fe.

The placement of the post office in Embree inspired a bitter feud that raged for two years, and an act of congress was required to settle the rivalry between Embree and Duck Creek. Congressman Jon Abbott of Hillsboro, upon the urging of Dallas County judge Tom Nash, moved the post office to a neutral location. The towns then merged, and the new community was named Garland in honor of Abbott's friend, US attorney Augustus H. Garland.

Although A.H. Garland was from Arkansas and never set foot in town, he was a fitting namesake. Like the US attorney in his own career on the national stage, the civic workers of the town of Garland have long exhibited strong leadership, ingenuity, and solid convictions in their contributions to establishing this community.

Garland has historically risen to the challenges it faced. From the city-owned power source of Garland Power & Light to leadership in the North Texas Municipal Water District, the community has met its needs. Today, the "Garland Spirit" has covered the old farming grounds of its origins with a diversified section of industries that first contributed to victory in World War II and now generates economic growth today. The rural village, incorporated in 1891 with a population of 478, now encompasses 57.1 square miles and 276,876 citizens. It was cited in 2008 as no. 67 of the "Top 100 Places to Live" in the United States. Currently, Garland is the 12th-largest city in Texas and the 87th-largest in the nation.

Since the times of its pioneer settlements, Garland has connected to the outside world and overcome the problems and natural disasters that have arisen in its history of growth. During the days of the Republic of Texas, the Texas National Highway ran just south of its boundary along what is now Barnes Bridge Road. Along with the railroads, Garland sought and became a part of the Bankhead Highway as that second intercontinental road was built in the 1920s. Today, it connects with both interstate and toll facilities to the largest metropolitan area of the South.

A series of natural disasters has only strengthened the spirit and determination of Garland's people. A fire in 1889 destroyed most of downtown, only to lead to city planning for its long-established downtown square. A tornado in May 1927 and a memorable flood in June 1949 both drew heroic efforts by the community to rebuild and improve.

That strong spirit of "do something" enabled the pioneers and settlers of Garland to overcome feuds, supply their own sources of power and water, and build a strong community adapting to its present growth and challenges. Gladys Nash Peavy described it best in a 1986 *Garland Perspectives* interview, saying, "The people themselves were just especially energetic or interested or entertaining, and churches have had a lot to do with it . . . they felt they got so much to make living worth-while."

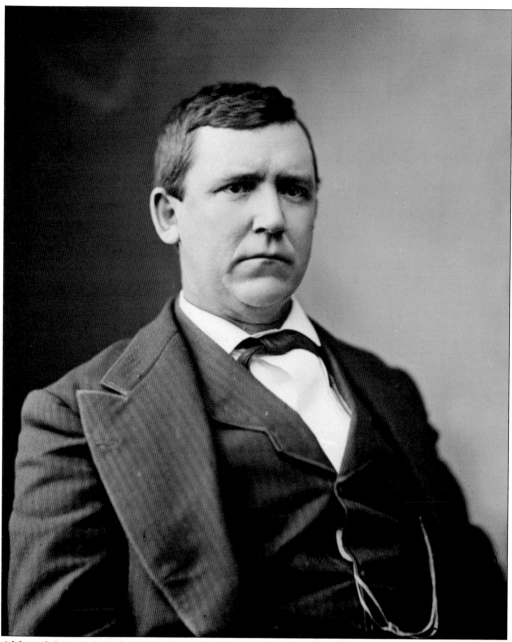
Although he never set foot in Texas, much less the town that bears his name, Garland's namesake, Augustus H. Garland, was the attorney general in Pres. Grover Cleveland's cabinet. Garland's friend, Texas congressman Joe Abbott, negotiated the merger of Duck Creek and Embree to form Garland. (Author's collection.)

One
BECOMING GARLAND

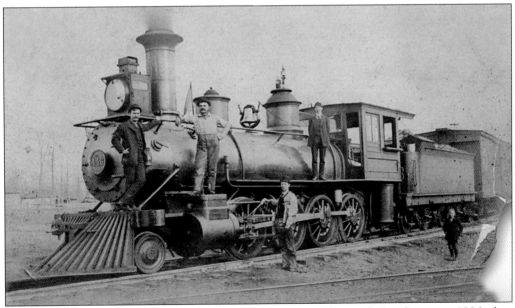

When the Katy and Santa Fe Railroads both crossed into the Duck Creek area in 1886, they bypassed the original settlement of Duck Creek by a mile. This resulted in a bitter rivalry between the newly formed communities of (new) Duck Creek and Embree that centered on the railroad depots.

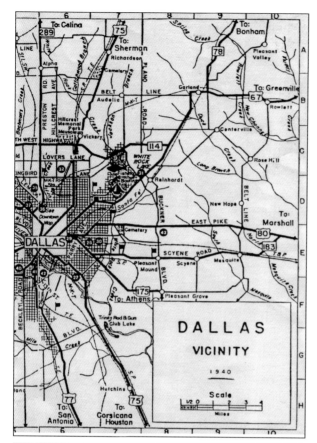

After Garland was formed from the merger of Duck Creek and Embree, it annexed other local communities during its growth. Notably, Rose Hill and Centerville were added by 1950. Other unincorporated communities included Wyrickville, Cunningham, Bobtown, Shiloh, and Morris.

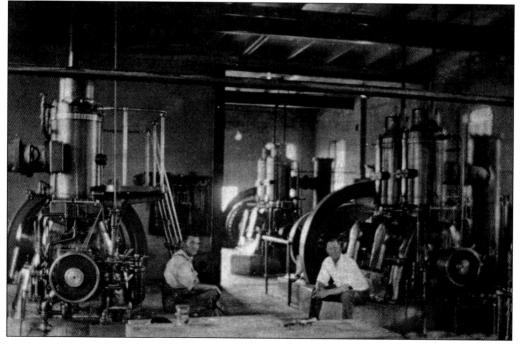

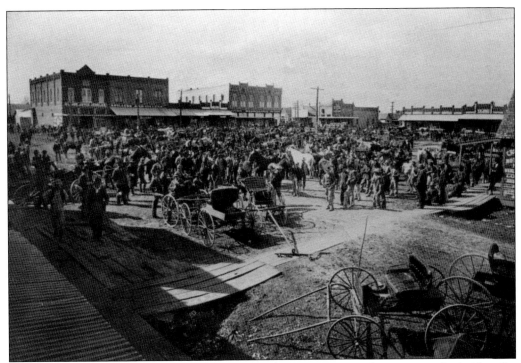

Trade days for businesses were usually held on Mondays. To accommodate women, plank sidewalks were added. Many merchants also extended bargain sales to attract customers from the surrounding farming communities.

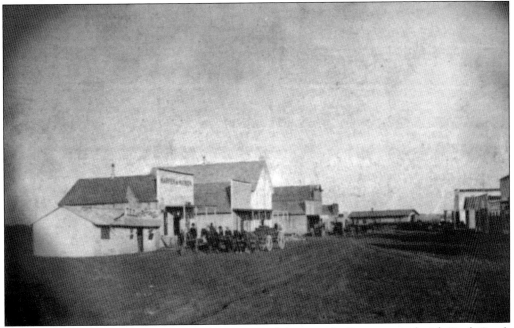

This view of Embree in 1887 is the earliest image of the town before it merged with Duck Creek to become Garland. It shows Mewshaw Street (now Avenue D) between what is Glenbrook Drive and the first Santa Fe depot to the east.

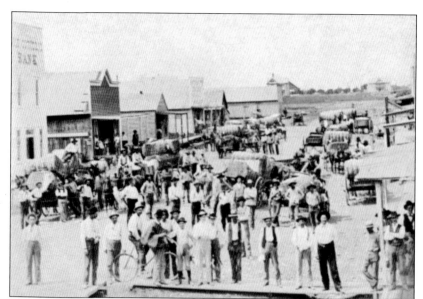

This c. 1912 photograph was taken facing west along the current State Street. It represents a typical view of a busy trading day. Much of the activity centers on cotton farmers selling what was a popular crop that year.

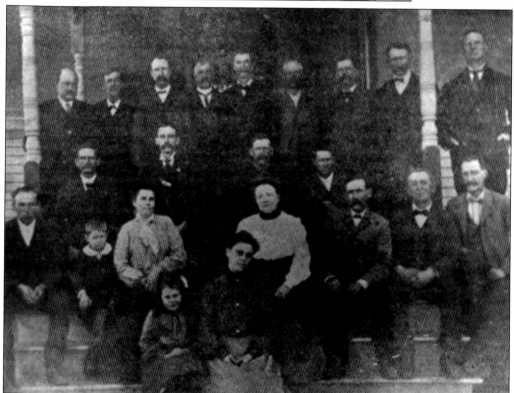

The surviving settlers of old Duck Creek organized a club in 1900. Those original Duck Creekers included, from left to right, (first row) Johnnie Ryon and Mrs. L.S. Darling; (second row) Enclid Ryon, Peter Witwer Handley, Mrs. Ida (Nix) Handley, Mrs. J.H. Ryon, Tom Ware, F.L. Crush, and Geo. Wallace; (third row) W.L. Handley, John H. Cullom, H.J. Castle, and Pater Handley; (fourth row) Dr. F.L. Ramsey, Wm. McDonald, A.J. Beaver, Dr. J.H. Ryon, H.C. Smith, Charley Kinnon, Tom Raney, Dr. T.S. Walker, and G.W. Crossman.

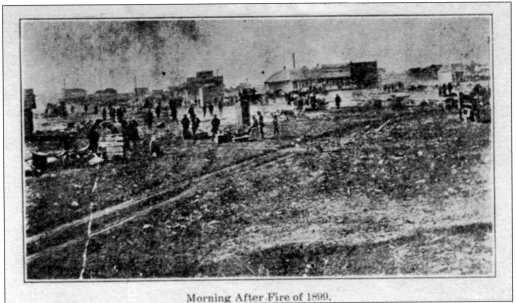

Morning After Fire of 1899.

This rare photograph from the 1912 *Silver Edition Garland News* is the only depiction of the remains of downtown the day after the fire of 1899 that burned most of the wooden business structures. That event resulted in downtown businessmen purchasing land for the town square and rebuilding with brick edifices.

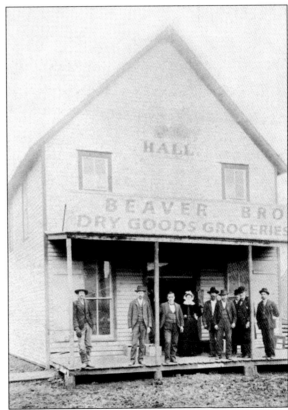

The store of Andrew and J.T. Beaver was moved from old Duck Creek after it survived the fire that destroyed that town. It was relocated to Embree, and its second floor provided a community hall that housed weekly meetings of a literary society.

This turn-of-the-century social meeting included some of Garland's ladies entertaining out-of-town guests near Garland. (Courtesy of the Garland Landmark Society.)

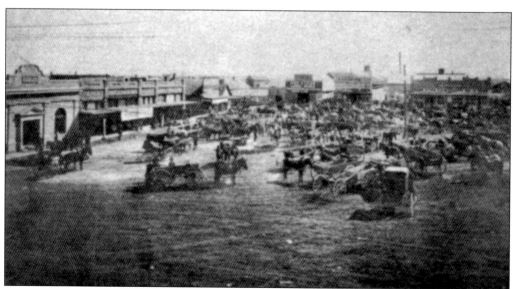
This is a view of the Garland Square facing southeast around 1906. On trade days like this one, farmers would spend the day banking, acquiring merchandise, and meeting neighbors.

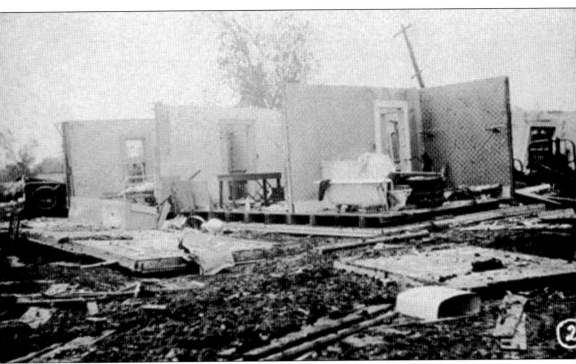
The historic tornado that struck Garland very early on the morning of Sunday, May 9, 1927, galvanized the community. It was a tragic event, resulting in the loss of 14 citizens, including former mayor S.E. Nicholson.

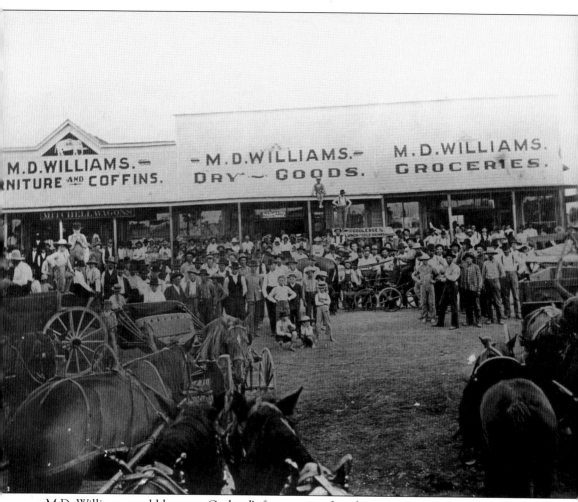

M.D. Williams would become Garland's first mayor after the town's incorporation in 1891. His furniture-supply store included mortuary goods and eventually resulted in a funeral business that would become Garland's oldest business after 120 years.

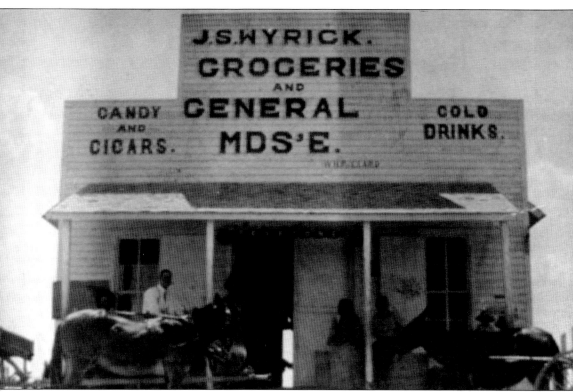

The J.S. Wyrick General Store sat on Jupiter Road near Garland. John S. Wyrick graduated from Garland High School, attended the University of Texas at Austin, and later settled on farmland near the Dallas Pike, the main road from Garland to Dallas. The rural community of Wyricksville also included a blacksmith shop and a Model T garage. Wyrick added more stores in Dallas and Reinhardt.

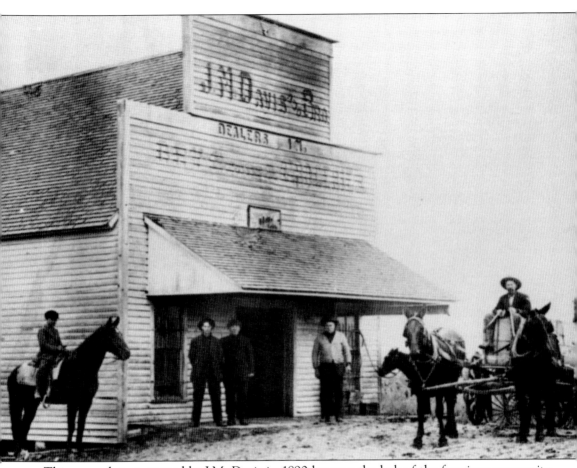

This general store opened by J.M. Davis in 1890 became the hub of the farming community of Centerville. Today, Centerville Elementary School sits a few yards from the location of the original store. (Courtesy of the Garland Landmark Society.)

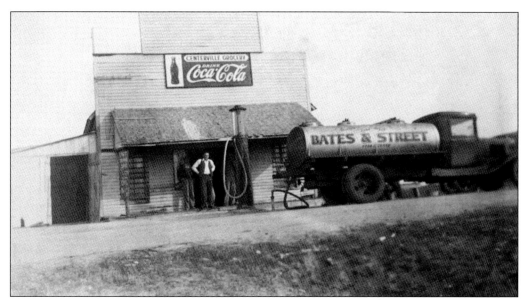

The Centerville Store remained open until the 1950s when the last owner, Sam Shipley, built a service station across the street. The original store sat approximately on the current site of Walgreen's, where Beltline, Kingsley, and Centerville Roads meet.

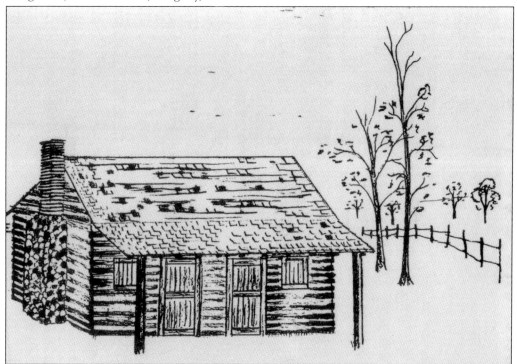

This is a depiction of the William Anderson cabin, which sat near the Anderson Cemetery in the original location of Rose Hill from about 1850 until it burned in 1930. The summit where it sat overlooking Rowlett Creek is now a few yards from the west marina on Lake Ray Hubbard. The first Rose Hill community developed from the 1890s near Bobtown, Zion, and Lions Roads. (Courtesy of Jenny Flook.)

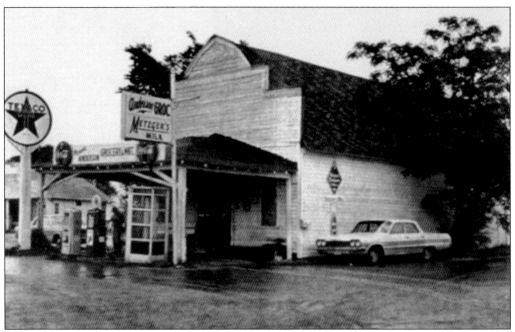

Although a post office was established in 1884 in Dan Housley's store, the general community continued to be called Rose Hill. Anderson's service station/store sat at the intersection of Rose Hill and Rowlett Roads. As the village shifted north to that location, it usually serviced between 50 and 75 citizens. The store closed in the 1960s as Garland absorbed Rose Hill.

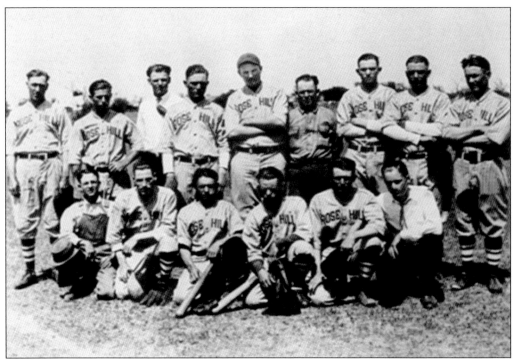

Baseball was a popular sport for post–high school teams formed in the local communities. This Rose Hill team from 1925 had a winning season with a record of 7-4 that year.

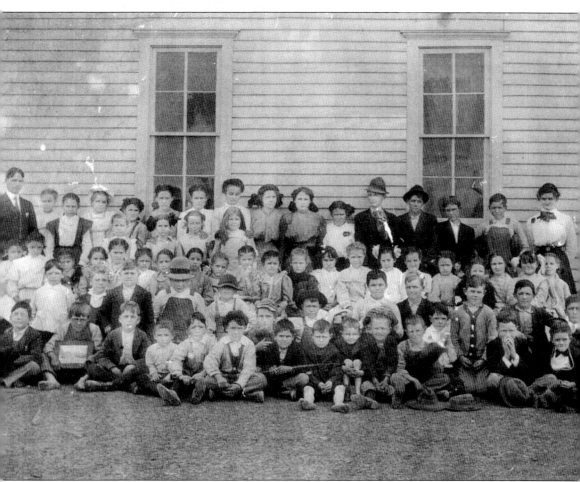

This is Tuckerville's Tucker School class of 1903. Tuckerville and the Tucker School were the products of the Jesse Fitzgerald Tucker and his family. The farm was northwest of Centerville Road at Castle Drive. The Tucker boys—Jessie, Dick, Lum, and William—organized a group of local families and built a one-room schoolhouse on the northeast corner of Castle Drive at Rowlett-Pleasant Valley Road in the early 1900s. The fascinating story of that industrious family is recorded in *Proud History III* by the Dallas County Pioneer Association. The school served the area for a dozen or so years before it and the community were merged into Rowlett and Garland. (Courtesy of Clifton Tucker.)

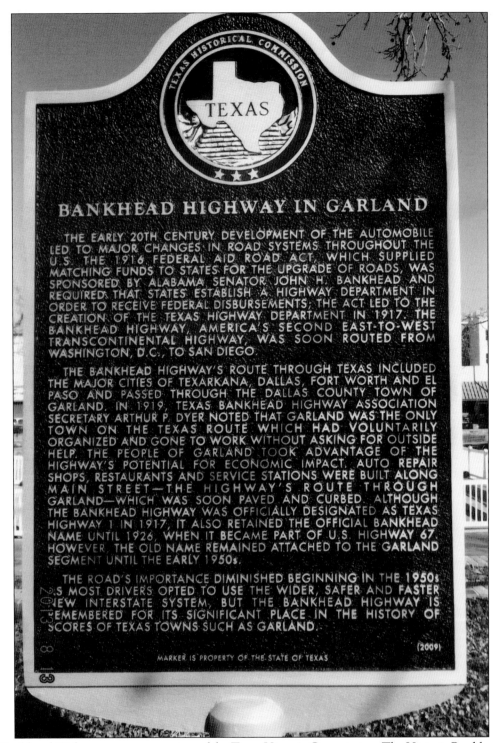

Bankhead Highway was a state project of the Texas Historic Commission. The Historic Bankhead Highway of the 1920s is being currently being mapped.

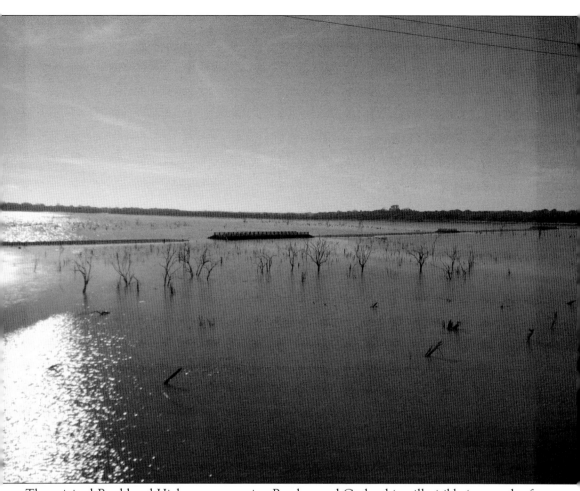
The original Bankhead Highway connecting Rowlett and Garland is still visible just south of Highway 66, covered by the waters of Lake Ray Hubbard.

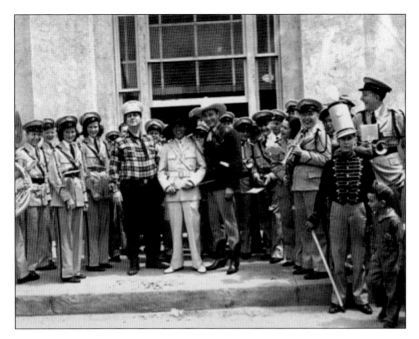

April 19, 1938, was a celebrated event along Bankhead Highway/Main Street of Garland when Roy Rogers (center, white hat) visited town to premiere his first major movie.

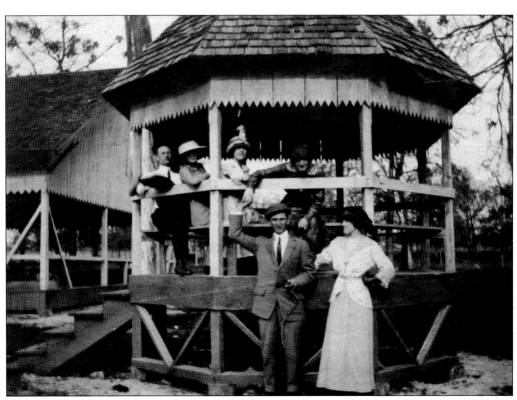

Both social and political events were celebrated in the pavilion facilities of Williams Park next to Bankhead Highway between Garland and Dallas.

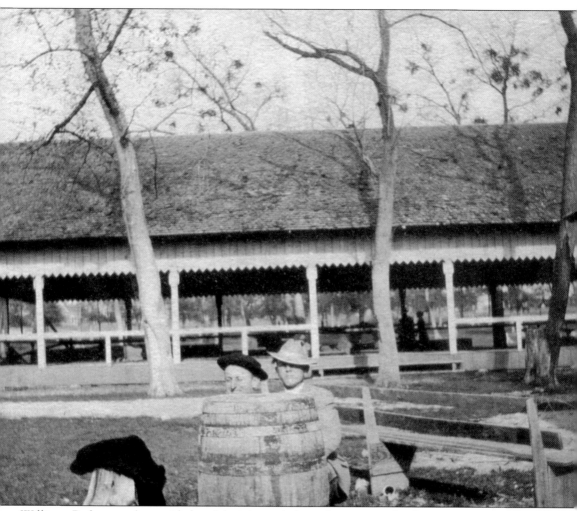
Williams Park not only provided social, civic, and physical recreation for the community, it also proved to be a "barrel of fun," as demonstrated by these two young men.

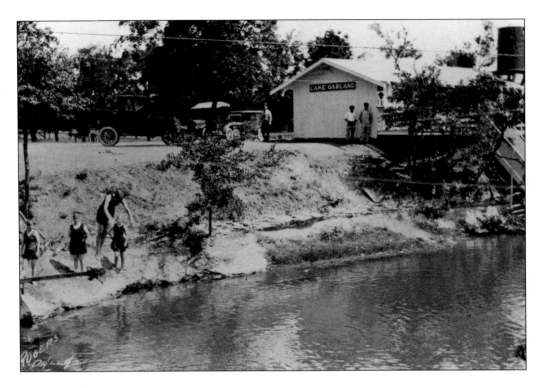

To facilitate both local and transitory traffic, the Williams family created Williams Park and Lake Garland in the 1920s and 1930s. Along with bathing and picnic facilities, the very popular swimming hole was well remembered.

Two
RURAL ROOTS AND COMMUNITY GROWTH

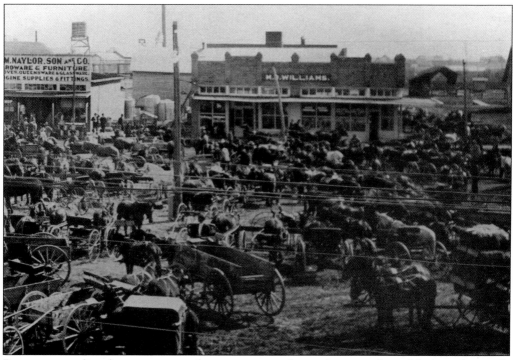

Downtown trading days were times of commerce, social interchange with neighbors, and resupply of staples for the household. They often fell on Saturdays, but many were held on Mondays. The tradition continues in Canton, Texas, today. Merchants would leave their doors open until 10:00 p.m. to accommodate the occasional trips to town by both rural northeast Dallas County farmers and visitors from surrounding counties. Service merchants like Nelson's Blacksmithing might work around the clock to finish requested repairs. On other occasions, farming families might extend visits on festive occasions, such as the Garland Stock Show of May 4–6, 1911, which was so well recorded.

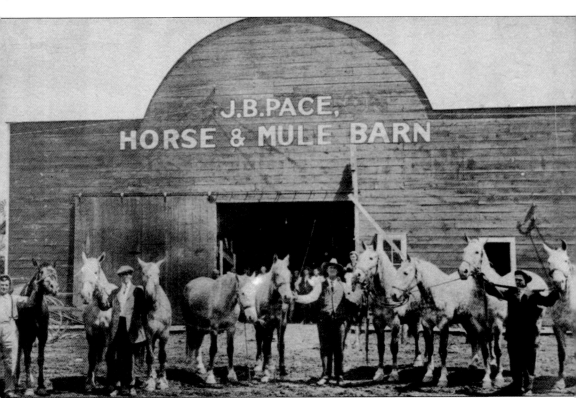

J.B. Pace advertised as a horse and mule dealer on a prominent, full page in the 1912 *Silver Edition of the Garland News*. He proclaimed, "[We] will buy and sell from single ponies to car load lots and from Missouri to the Gulf. Every animal we sell must prove as represented or money back without quibbling. Write, phone or wire me when you want to buy or sell. We go everywhere." His cable address and motto reflected a mission to always sell "good stuff."

A dollar promotion was a staple among downtown merchants in the spring of 1915. The square was barricaded from automobile traffic and the various forms of transportation to accommodate the thousands who enjoyed the promotion.

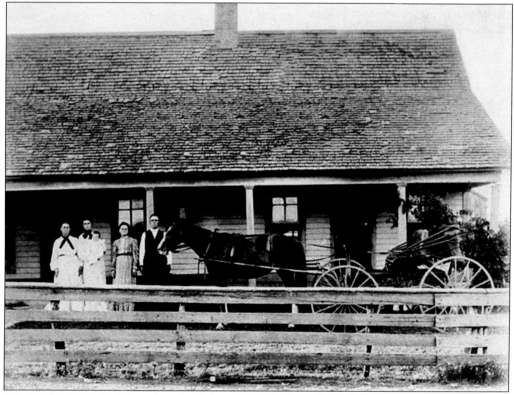

C.L. Nash inherited his farm from his father, T.J. Nash. It was located on what is now the warehouse on McCree and Garland Roads.

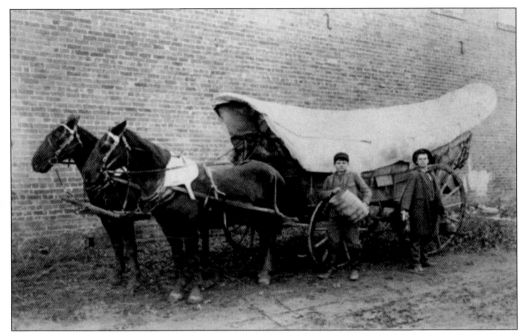

For many immigrants to the area, a reliable means of travel to Texas was the prairie schooner. This wagon held goods of the R.D. Jones family from Tennessee.

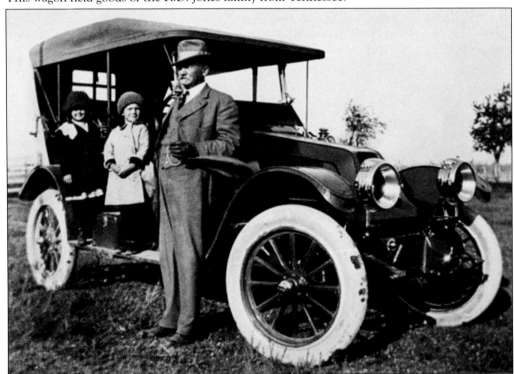

By 1912, Dallas County already had an estimated 1,200 miles of designated roads, though only one-third of them were paved. This air-cooled Franklin touring car was the vehicle of choice for John T. Jones of Garland.

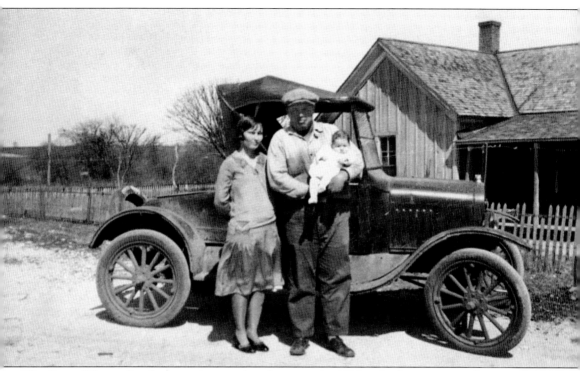

The Owen Wynne family is seen here at their home in the 1920s, which is now near the current Lon Wynne Park. Many residents moved on to more reliable transportation—like this tin lizzie automobile—after World War I.

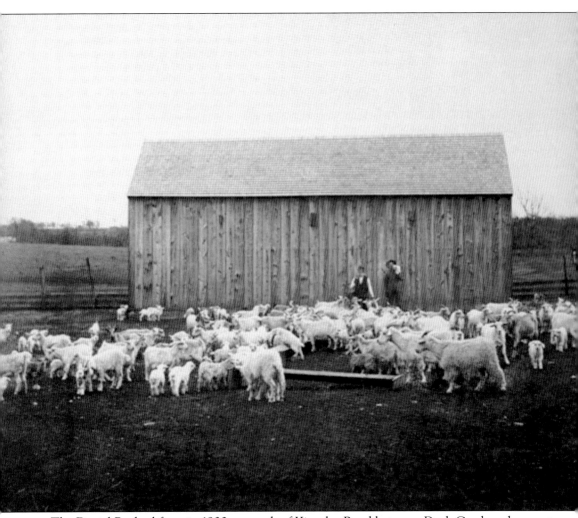
The Daniel Bechtal farm in 1900 sat south of Kingsley Road between Duck Creek and present-day Saturn Road. Among other products, the farm raised goats for meat and wool as well as for their excellent ability to clear the land.

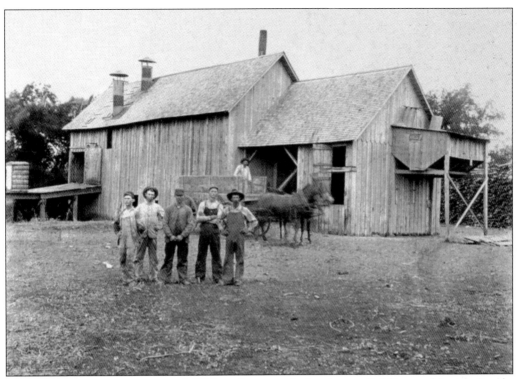

The Lyles Gin was active around 1900 in the area of what is now Beltline and Jupiter Roads. As cotton became a major staple on area farms, more gin operators began to open to service local needs.

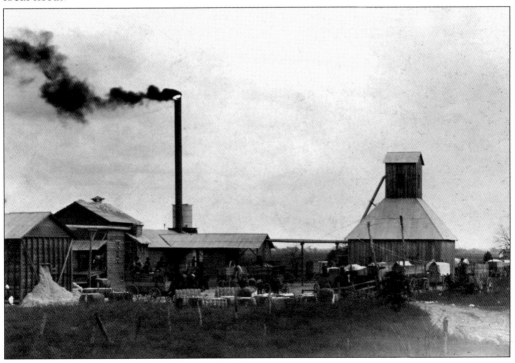

This site was a great addition to Maude and Millard Flook's farm around 1915.

Will C. Kingsley is an excellent example of the progressive can-do spirit of Garland's settlers. His ranch extended south of Kingsley Road across much of the property along Duck Creek and Glenbrook west to Saturn Road. Always innovative, he tried new techniques for farming and grazing. His prosperity led to involvement in banking and related businesses.

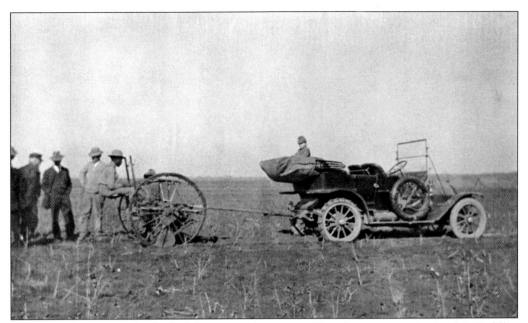

Never too shy to use what he had for practical purposes, Kingsley is pictured using his Cadillac touring car to explore new planting techniques around 1913.

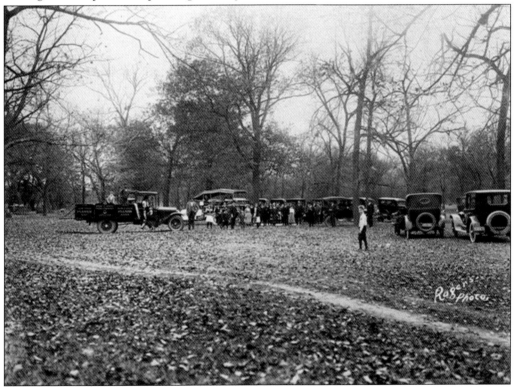

Will Kingsley was very open to social celebrations during the appropriate season. In the early 1920s, he ordered a piano delivered to his ranch for a fall party with invited guests in the area of present-day Glenbrook Drive.

The Nelson Blacksmith Shop sat on the exact spot on Fifth Street where Garland City Hall is now located. From 1927 until 1942, ? Nelson (standing) remained active in the business of blacksmith and woodwork service, and he later offered welding services. He is shown here with his son Pete (kneeling at left) around 1946. The shop was on the northeast corner of Fifth and State Streets.

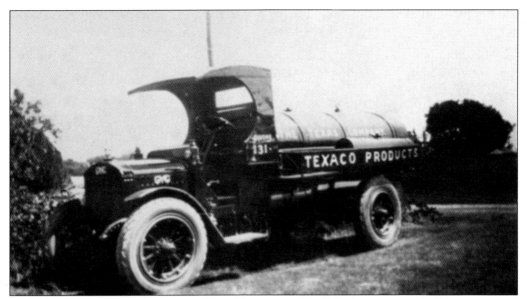

By the 1920s, Garland fuel distributor Oscar Skip serviced both farm operators as well as commercial interests. His tanker, with a 600-gallon capacity, supplied the growing service stations of Garland from the Dallas Texaco Depot.

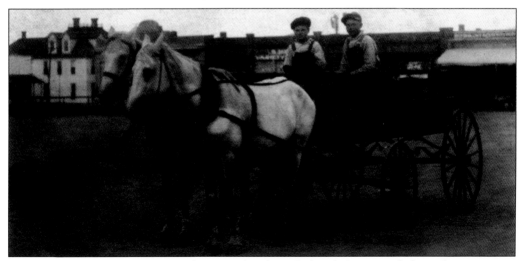

By 1915, the Garland town square began to be electrified with four streetlights. The square was still unpaved, and horse-drawn buggies remained common.

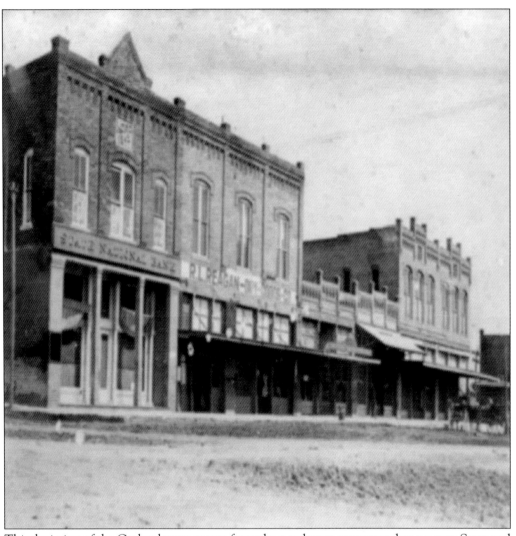

This depiction of the Garland town square faces the northwest corner at what are now State and Fifth Streets. The prominent building across the street is the National Bank. Beginning in 1895, a number of banks served in that location for more than 30 years. The building later became the Nicholson Memorial Library in 1933.

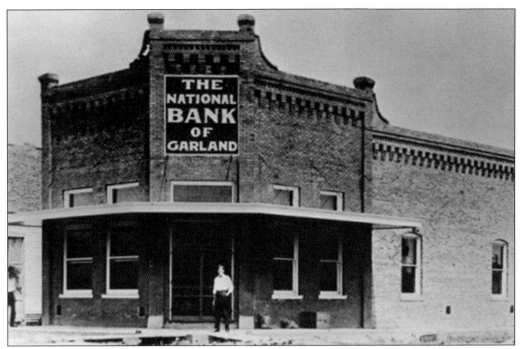

The First National Bank of Garland, located on the west side of the square, was the second bank organized in town. It stood next to the Garland News Building. A.R. Davis, the first cashier (and later president), is shown here in front of the bank.

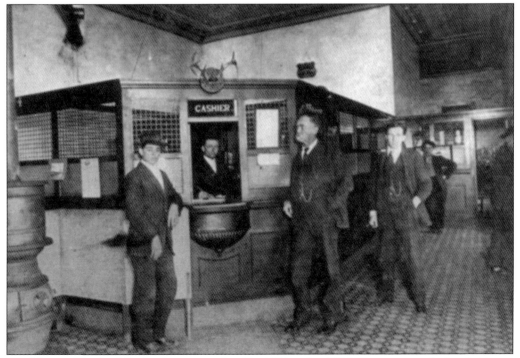

The National Bank of Garland was capitalized by 1906 with a $50,000 investment by local citizens. Its first president, John T. Jones, is seen here to the right of cashier A.R. Davis.

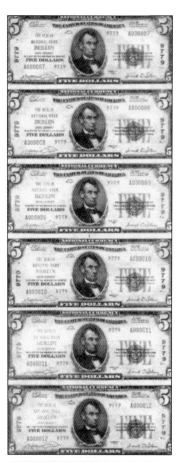

Many banks in the 1920s issued their own currency. These $5 bills were signed by Jones and Davis, the president and cashier.

Rather than have trading days, the downtown area of Garland began to have stores that traded items local farmers had to sell as well as items that were being produced nationally. This is the interior of the Penslar Store, which provided fountain drinks and delicious delectables. In the heat of Texas, the store advertised itself as "the coolest house in town."

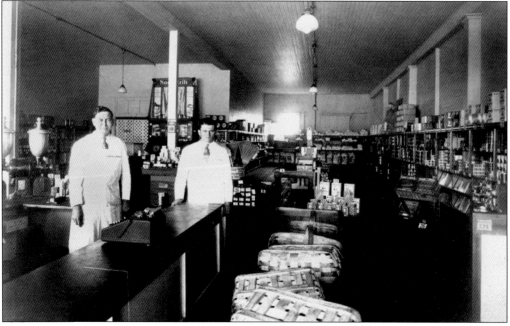

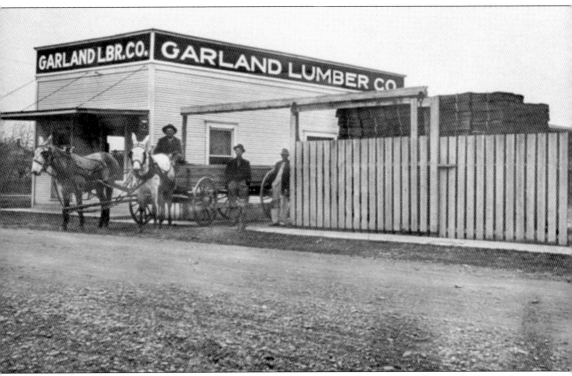
This image of the Garland Lumber Company in downtown is from 1915. The yard sat on the west side of State and Main Streets between Sixth and Seventh Streets.

The *Garland News* began in Duck Creek under John H. Cullom as the *Duck Creek News*. Upon the creation of Garland, the paper renamed itself the *Garland News*. It remained vital as a booster of the community through its final purchase by the *Dallas Morning News*.

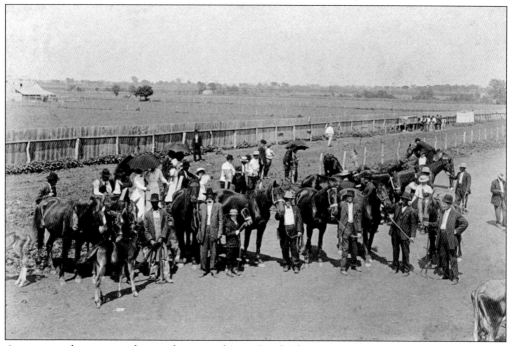

A very popular activity during the annual May Stock Show was attending the horse races. The Garland Track opened in 1908 northwest of present-day Avenue D and First Street. Animal breeding and training were available throughout the year, as well as during the May Stock Show.

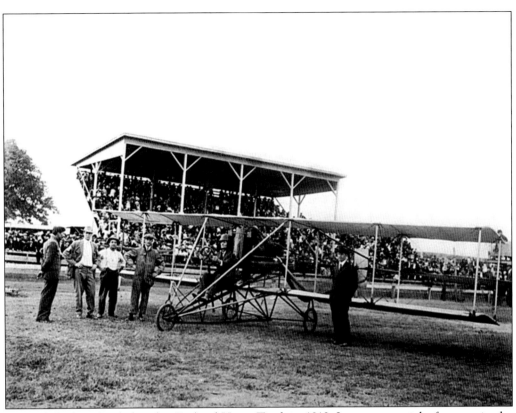

An early biplane landed at the Garland Horse Track in 1912. It was a rare sight for most in the rural community and a highlight of the Garland Stock Show.

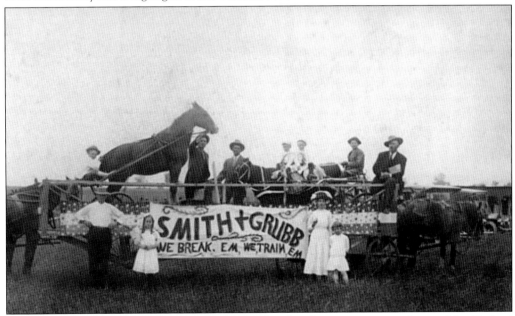

The popular Garland Stock Show was highlighted in the silver anniversary edition of the *Garland News*. Many local businesses contributed floats and advertised their businesses in the parades.

Parades were the continuation of townsfolk getting together to socialize and bring unity to a thriving community. The social interactions were more than just town celebrations, they were a reinforcement of the ideals of the United States and a collaboration of the rural environment staying connected to those within the township of Garland.

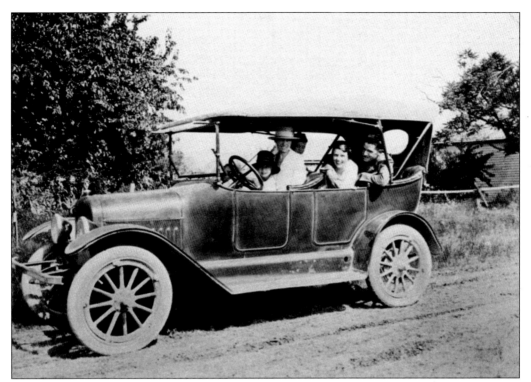

Many local papers, including the *Garland News*, began to map out Sunday-drive routes throughout the county. By 1917, families such as this one began to embrace the mobility afforded with the growing urban lifestyle. This 1917 REO touring automobile could hold up to seven passengers. This was at a time when fewer than 200,000 automobiles were registered in Texas.

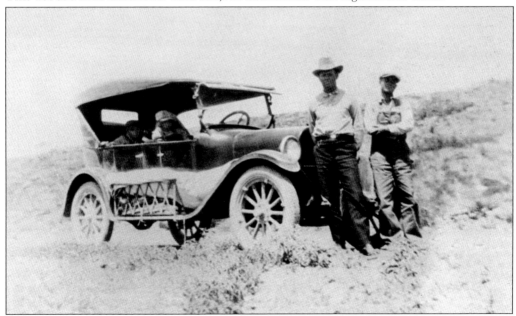

This Phantom automobile owned by Nash Long is an example of a typical touring car going out for a picnic excursion.

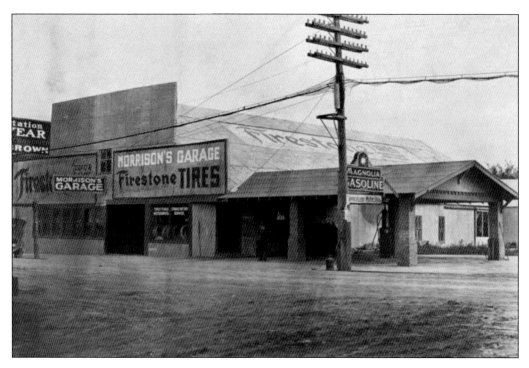

In 1910, A.V. Morrison's Garage was the source for fuel and maintenance for the growing number of motorized vehicles. Morrison was the authorized dealer for the Overland Automobiles Company in Dallas. The garage sat for many years on the southeast intersection of Main and Seventh Streets.

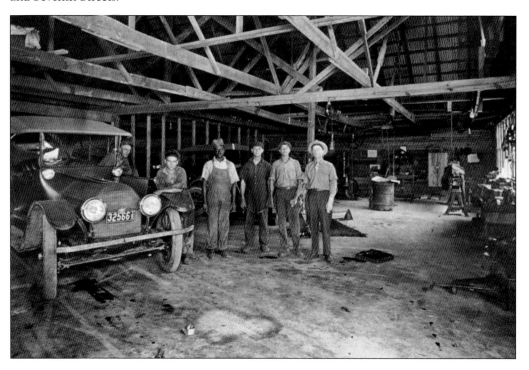

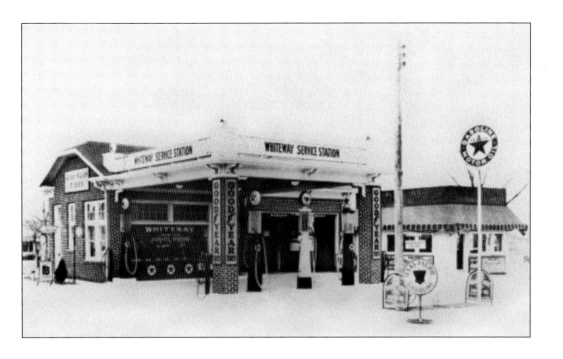

The first classic, standard station was opened in Garland by Fletcher White on January 1, 1930. It stood on the corner of the Bankhead Highway and Seventh Street.

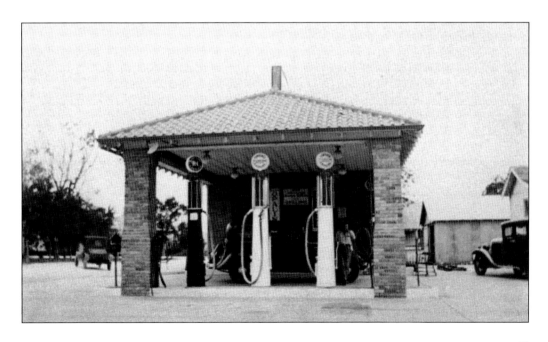

Jackson-Olinger Chevrolet began on the square in downtown Garland in 1925. After Jackson bought out the dealership in 1937, he later brought his son-in-law J.E. Newman into the business. Newman's son-in-law Mike Matetich has continued the transfer of the family dealership. The second floor of the business was well remembered as the best seat for downtown parades. (Courtesy of Jupiter Chevrolet collection.)

Ben Jackson (left) and J.E. Newman (right) built one of the oldest car dealerships in Dallas County.

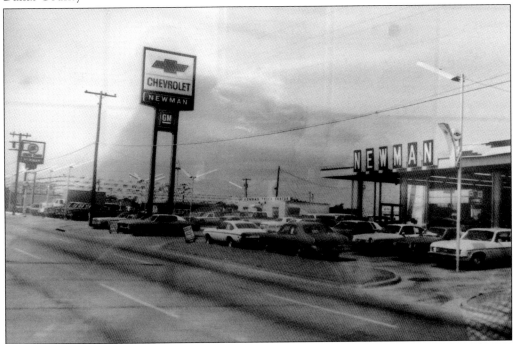

At 11611 Lyndon B. Johnson Freeway, Newman Chevrolet, the predecessor of Jupiter Chevrolet, sat on South Garland Road (1958–1997) as part of the "money saving mile" of dealerships positioned along Garland Road and Northwest Highway. (Courtesy of Jupiter Chevrolet collection.)

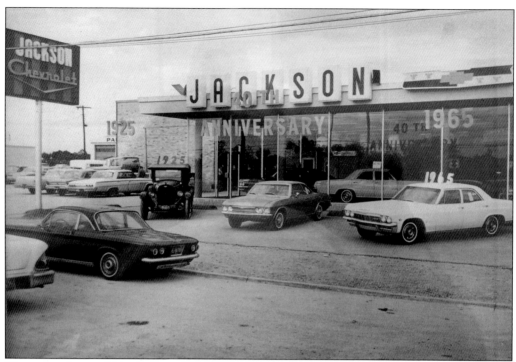

The original car sold by Jackson-Olinger in 1925 was later repurchased and refurbished. It now sits in the front showroom of Jupiter Chevrolet. (Both courtesy of Jupiter Chevrolet collection.)

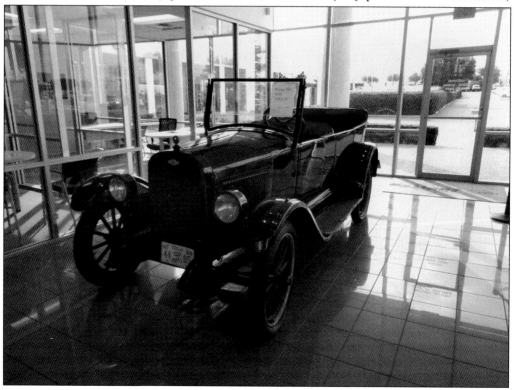

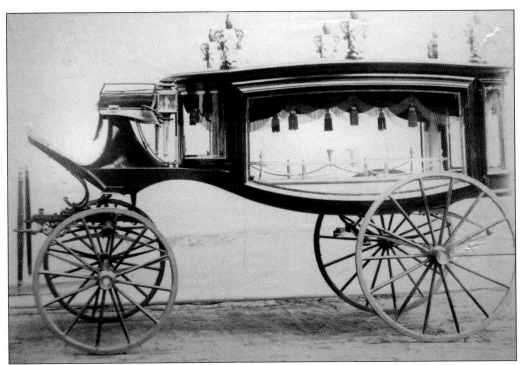

Rarely does a family business succeed for more than three generations. The Williams family has been in business for 120 years and over six generations. The business began before the beginning of Garland's creation. As detailed in the first chapter, Williams provided furniture, goods, and coffins. Williams Funeral Directors has become one of the oldest funeral facilities in Texas and the United States. It has served Garland well with thoughtful consideration of citizens' final needs. Above is a late-19th-century hearse. The two 1923 ambulance-hearse models below were made by Sayers & Scovill.

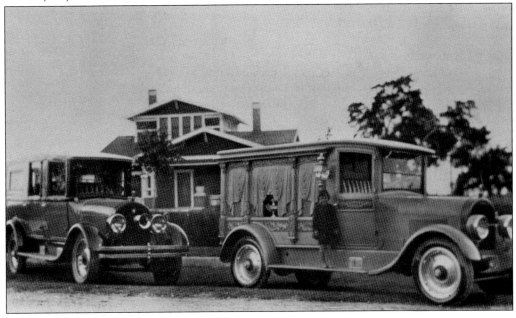

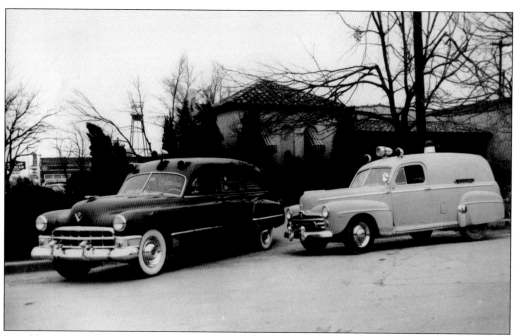

In addition to the final needs of residents, the Williams family also serviced the community with ambulance facilities during the boom period of postwar Garland. Note the city water tower in the background. It sat to the south of downtown until 1968 and served as a guide to many travelers to the area.

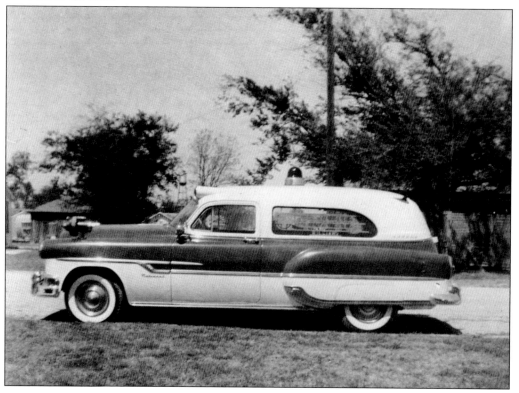

Three

POSTWAR INDUSTRIALIZATION AND SUBURBIA

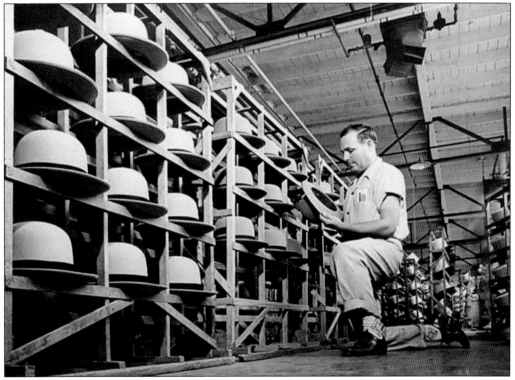

The industrialization of Garland from its rural origins began around 1937–1938. The Byer-Rolnick hat factory (today owned by Resistol) set up a factory here. KRLD-Radio built its first radio tower on Saturn Road.

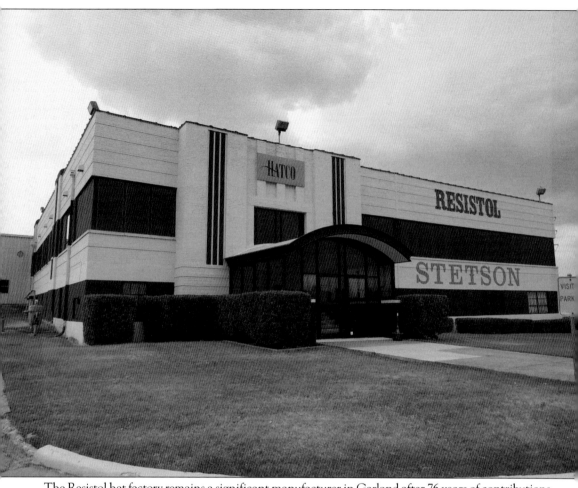

The Resistol hat factory remains a significant manufacturer in Garland after 76 years of contributions to the community.

The Dallas-Garland Airport, the most local airport Garland has ever had, sat on Northwest Highway and Garland Roads on property that is now soccer fields and the sites of Sam's Warehouse and Fry's Electronics. The completion of the Lyndon B. Johnson Freeway in the early 1970s disallowed the main runway's access. In its day, it was always a heart-stopping experience to have low-flying aircraft buzz the cars at that busy intersection.

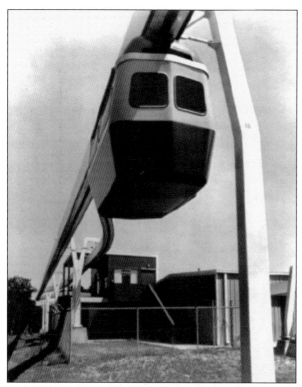

This monorail prototype was built by Varo in the early 1970s at its site on Walnut Street. It did not suit the specifications of Dallas–Fort Worth Airport for a tram system, so it was discontinued as a project.

Luscombe Airport Corporation opened its facilities on Jupiter and Miller Roads in the 1940s. Later, the location was owned by E-System, and now by Raytheon. One product it developed was the Silvaire airplane, which was lightweight but durable, with the ability to hold 3,500 pounds on its wings, or, as the advertisement below shows, two dozen employees. An airstrip at the back of the property utilized other various equipment and inventions to carry Garland into the world of manufacturing and innovation.

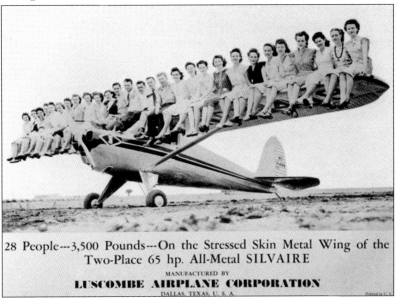

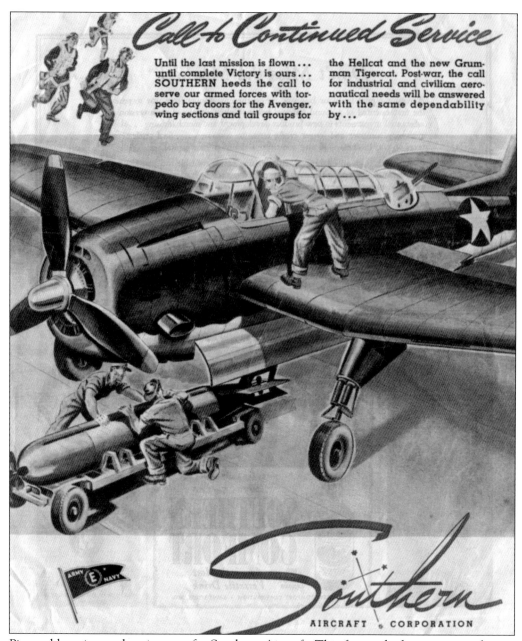

Pictured here is an advertisement for Southern Aircraft. This featured ad ran nationwide in a number of magazines in the 1940s.

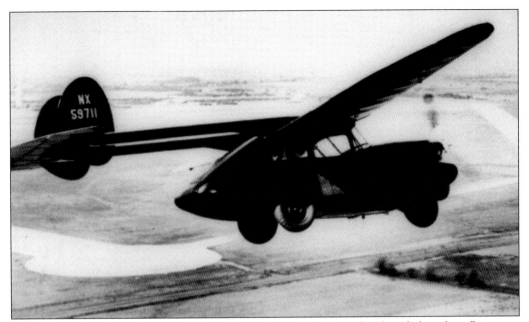

After World War II, A. Theodore Hall of Consolidated San Diego developed plans for a flying car. Dubbed the "Roto-mobile," a prototype was built and flown to Greenville, Texas, and San Diego, California, by pilot C.T. Prescott. Ruth Buchholz has written a history of Southern Aircraft that covers that "car-plane" as well as Southern Aircraft's other various creations made in Garland.

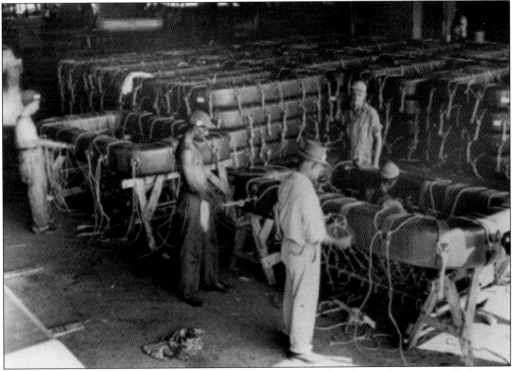

For a time, lifeboats were built in 1945 at Southern Aircraft. The facility eventually became Intercontinental Manufacturing Company; it is now operated by General Dynamics.

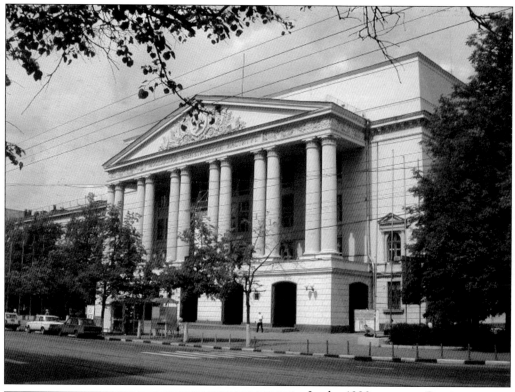

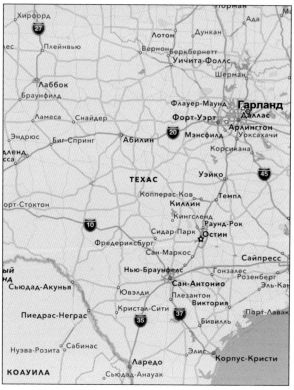

In the 1990s, a young Russian-language student from the University of Texas was in Moscow, Russia, and noticed a map in the lounge area at the Moscow Energy & Power Institute like the one seen to the left. On it, the capital of Austin was small, Dallas was a little larger, and Garland was written larger than either of these well-known cities. Years later, it was understood by the student that certain military equipment being manufactured at Intercontinental was the reason the former Soviets knew where Garland was located. (Courtesy of Michael Shaw.)

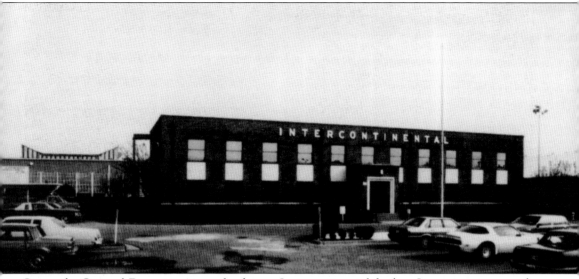
Currently, General Dynamics owns the former Intercontinental facility. It continues to stand today as a strategic industry of employment in the city of Garland as the premier manufacturer of bomb shells in the United States.

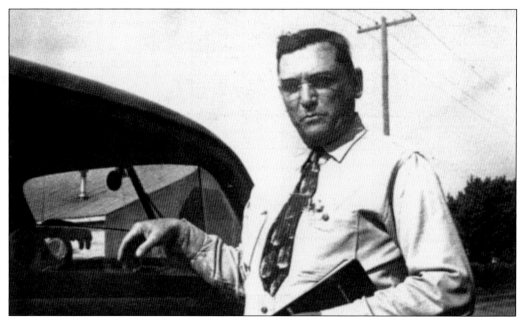

Charlie Newman (1895–1966) could easily be remembered as "Mr. Garland" or "Mr. Energy" for his contributions to the development of Garland. More details are available in the book *Charlie Newman and the Town Pump* by William P. Lord. When Garland went its own direction to supply electricity to its citizens without Texas Power & Light, it was Newman (above and below, second to the right) who spent a lifetime perfecting the process at Garland Power & Light (GP&L). (Courtesy of Garland Power & Light.)

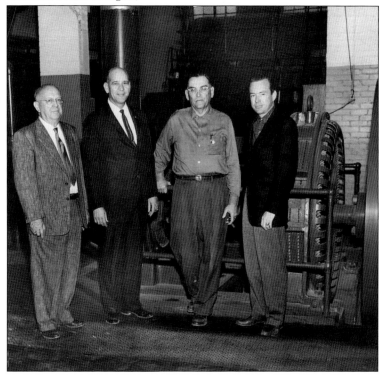

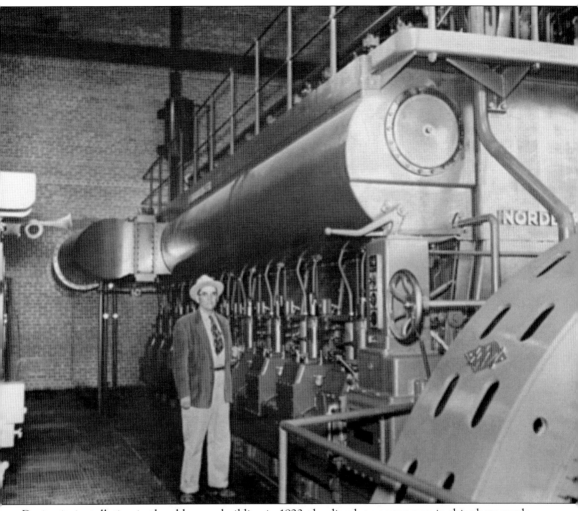

During its installation in the old power building in 1923, the diesel generator seen in this photograph next to C.E. Newman was so loud it would often shake the windows of nearby buildings. (Courtesy of Garland Power & Light.)

The original GP&L power plant still stands vacant on Avenue E as a great monument to the self-sufficiency of Garland in its formative stage.

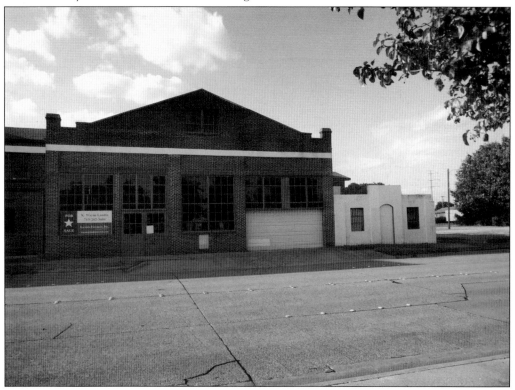

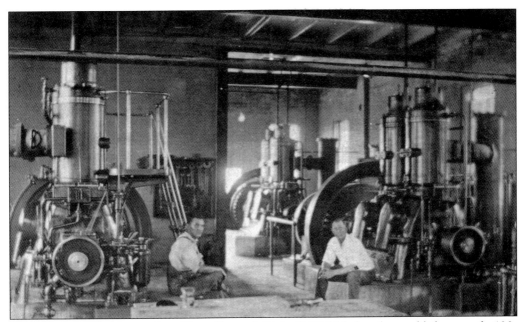

The dispute over rate costs from Texas Power & Light (TP&L) led to the establishment of a 100-horsepower generator on credit from the Fairbanks Morse Company. On April 1, 1923, Garland began operating with 300 customers. Today, GP&L is the fourth-largest municipal utility in Texas, serving an estimated 68,000 people. It is the 41st largest power company in the nation. This is a great testament to C.E. Newman's leadership in the industry.

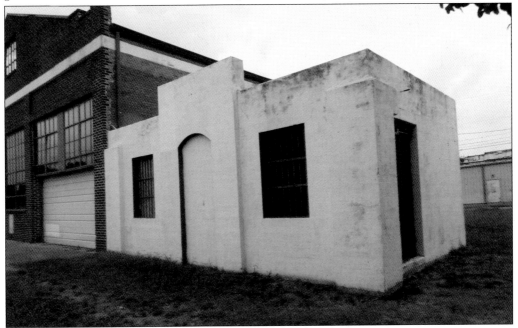

The white building east of the original power plant was the city jail. The practical administration of Garland officials figured they had an operator at the power plant 24 hours a day, seven days a week, and thus decided to use these resources to heat the jail as well as keep an eye on any overnight "guests."

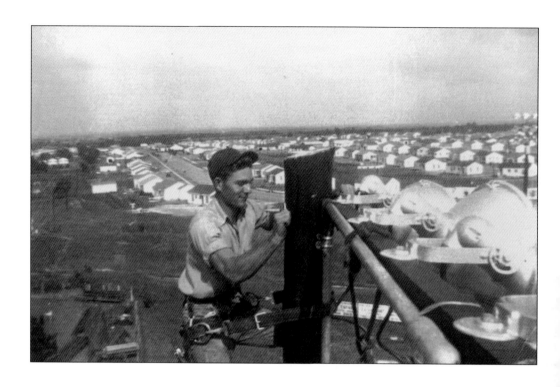

A booming Garland population in the postwar 1950s and 1960s created constant demands on GP&L crews. (Both courtesy of Garland Power & Light.)

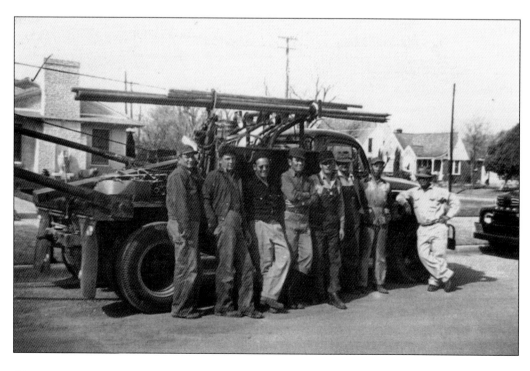

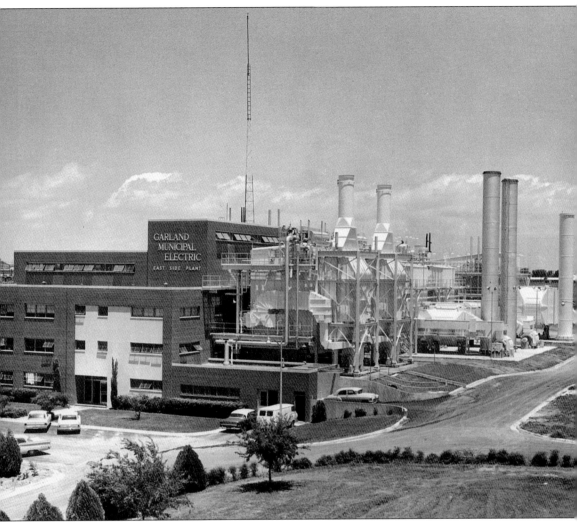

The east side C.E. Newman Plant has been discontinued in recent years due to increased demands and development. Currently, GP&L and partners in the Texas Municipal Power Agency utilize two gas-powered generating plants as well as the coal-fired Gibbons Creek Power Plant. (Courtesy of Garland Power & Light.)

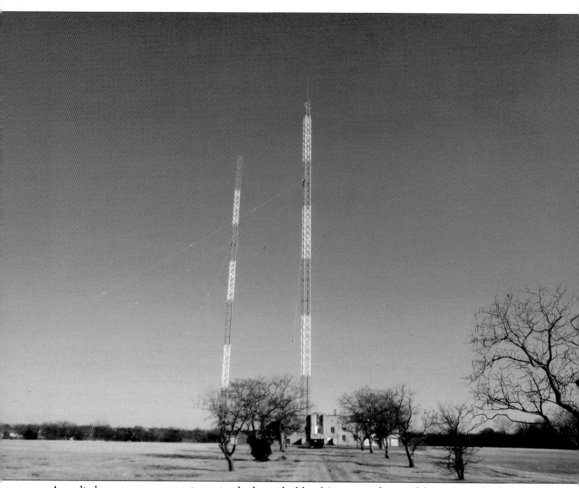
As radio became more prominent in the households of America, the need for airwaves and electricity also increased. Here is the famous KRLD-Radio tower that supplied much of the information to the local community, especially during World War II.

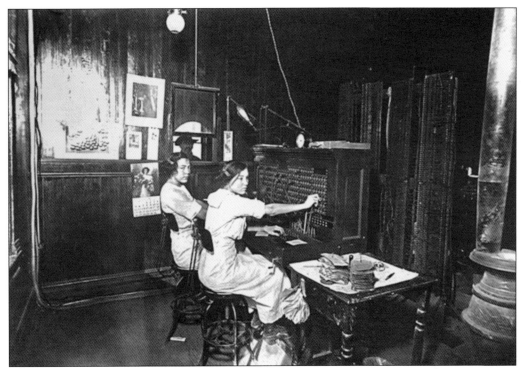

Garland also began to increase communication via telephone services, as seen here with the local telephone operators.

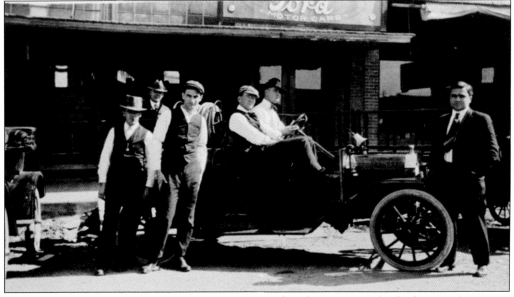

The community's volunteer fire department received its first motorized vehicle in 1917.

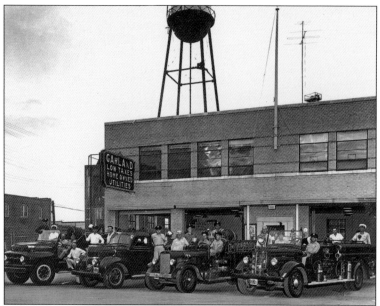

An excellent history of the Garland Fire Department can be found in *The Commemorative Album of 1915–2006*. Since destructive fires in 1889 and 1899 challenged early Garland, the author, Paul Henley, assessed that Garland was "forged in fire." From its earliest history, Garland has been sensitive to fires, and it has maintained a substantial volunteer force of firefighters for many years.

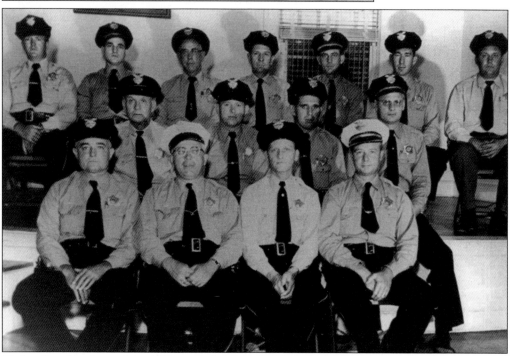

Garland's police force of the 1950s included, from left to right, (first row) Chief Burd Boyd, Henry Ashley, Jack Keller, and L.P. Trammell; (second row) Irv "Huff" Huffaker, Luke Steenburg, J.E. Mitchell, and Don Raines; (third row) Bobby Bradfield, Boyce Crumley, Lee Hurdson, Sam Davis, Jim Hardin, ? Ward, and Tom Harrod. Of special interest is the background of Huff, who began working with the police force in 1941 when it consisted of two men and the chief. It was Huff who worked the night shift and kept an eye on the water tower light signal in case of emergencies. With no two-way radios, cell phones, or other modern conveniences available, it took a lot of dedication and observation to keep things truly quiet in the sleepy, growing village of Garland.

Before the Austin Street Station opened in 1968, the Central Station downtown was next door to the original GP&L power plant and water tower. In the early days, a series of taps on a bell determined the direction of a fire. In later years, a whistle off the exhaust of the power plant diesel was used for the alarm. Some years later, sirens attached to the downtown water tower were utilized as a way to alert the fire station of a fire. (Courtesy of Garland Power & Light.)

Over the years, more modern equipment changed old techniques. One firefighter has stated that the traditional trampoline-catch approach to rescue is no longer used. He stipulated that now firefighters "prefer to take [those rescued] down slowly."

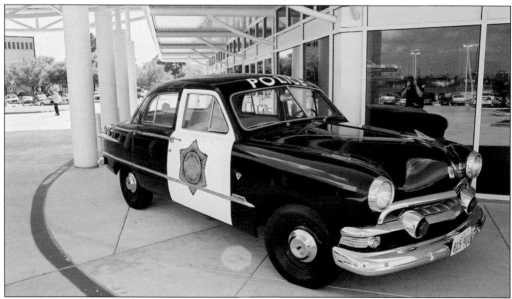

When Garland hired Grady McMahan as its first chief of police on August 1, 1951, the police department was housed at 613 West Avenue A and the old Works Progress Administration city jail at 500 West Avenue A. The first squad cars were 1951 Fords, similar to this refurbished model. The flashing lights were in the cone section of the grill, and a wind-up apparatus was used for a siren. At first, no car radios were available, so a flashing light was installed on the city water tower for a signal. Any emergency calls depended on the officer on duty keeping an eye on the signal.

Below, Garland's finest are gathered on the old airstrip behind E-Systems (now Raytheon). Joe Hern of the Garland Police Department recalled that, at least through the mid-1970s, pursuit practices were run on that facility site.

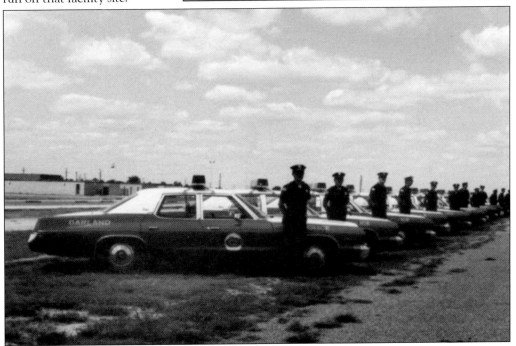

The SWAT team practices definitely had their ups and downs in preparing to ensure public safety.

Four
BOOM AND GROWTH

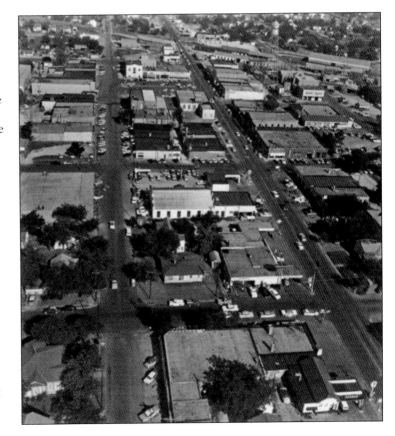

The postwar growth in Dallas County, particularly in Garland, began to be more pronounced from the 1960s to the 1980s. The rural farmland of the past continually became covered in housing and streets. The growth in industrial warehouses, new technologies, and the desire to live outside of Dallas made Garland a target for growth. In the crest of those waves of change, the schools, churches, entertainment venues, and family life in the suburbs all dealt with the bittersweet development of a new era. This aerial view of downtown Garland is looking east along State and Main Streets around 1960.

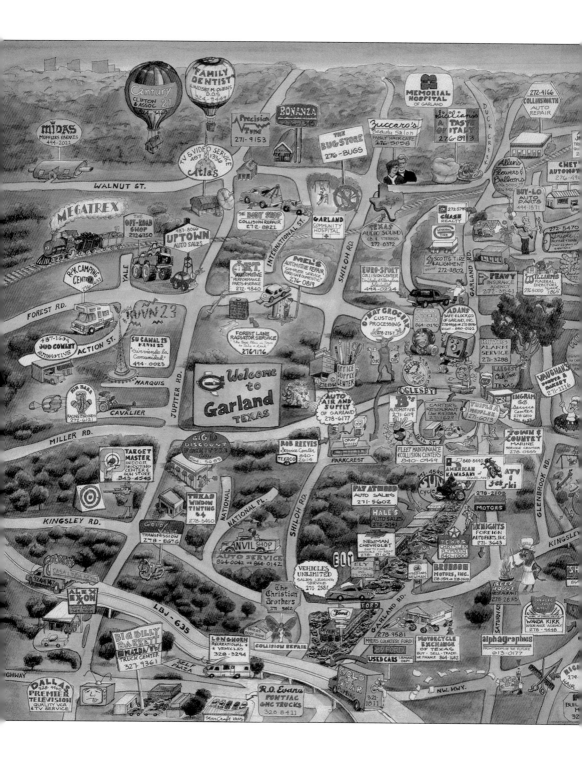

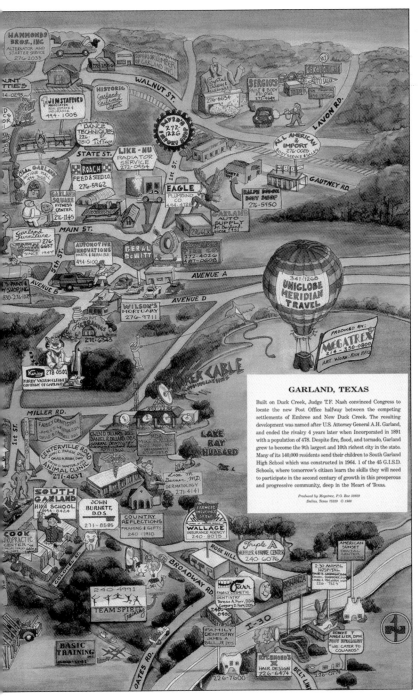

This caricature map of Garland was created for Hale Automotive in 1988. Of special interest is the depiction of the "money saving mile" of car dealerships along Garland Road and Northwest Highway. (Courtesy of Randy Hale.)

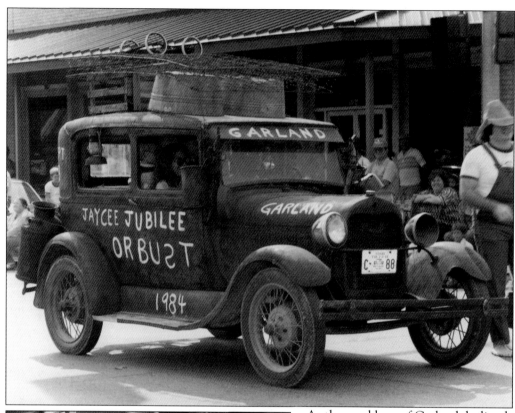

As the rural base of Garland declined, so did the annual stock shows. The postwar boom generations picked up the tradition with their own seasonal parades hosted by the Jaycees. The flavor of small-town America has often included annual parades, usually at Christmas and Labor Day. That tradition continues even now with other city events for the public on Labor Day. (Courtesy of City of Garland.)

Parades continued to anchor the traditions of rural Garland residents for the suburban population. Preparations for the Labor Day celebration in postwar times were a major event of the year.

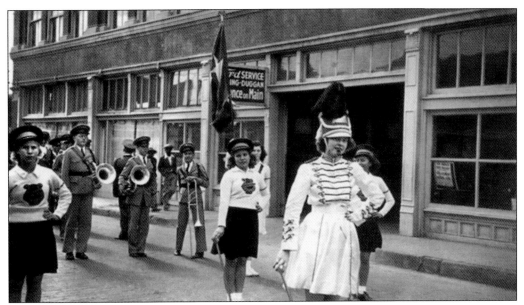
This Garland High School band was involved in the 41st Armistice Day parade in downtown Dallas. Martha Tucker was the majorette.

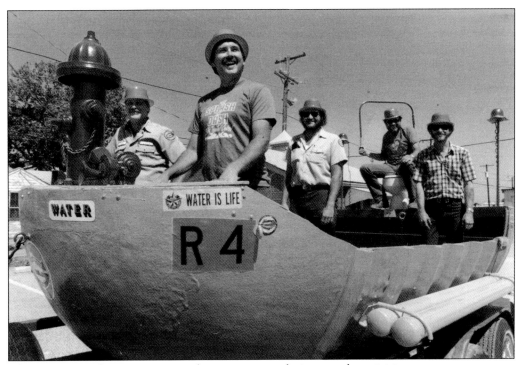
The city's water department created its own events during parade activities.

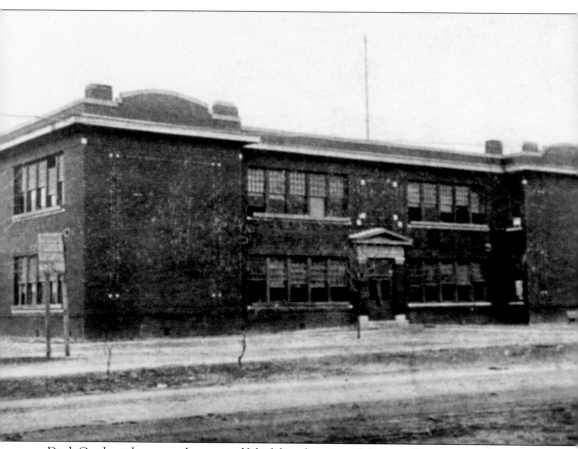

Duck Creek settlers were always mindful of the education of their youth, even as early as 1852. A series of one- and two-room log cabins were built to accommodate the growing rural populace. The schools usually were seasonal, with the buildings serving dual purposes for union church and civil events. A more formal multigrade system was employed by the 1880s with the establishment of Duck Creek Academy and, later, Duck Creek High School. The old red schoolhouse was first opened for the 1899–1900 school year. It housed grades one through eight for grammar school classes. High school grades were taught on the second floor until completion of the Central High School in 1936. This building was replaced with the current one-floor structure on Ninth Street at Avenue A and Avenue B after the fire in 1946. (Courtesy of Garland High School.)

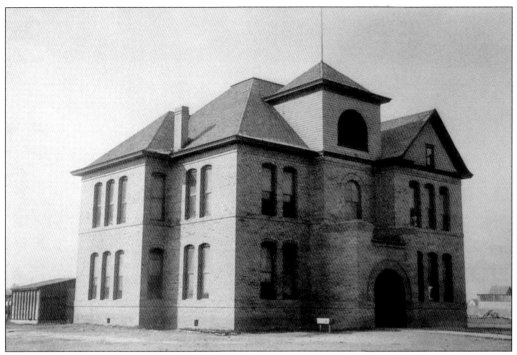

This building was originally erected by a nonprofit group known as the Garland College Association. When the Garland Independent School District was created in 1901, it assumed responsibility for the school's operations. Significant improvements and expansions were added by 1912.

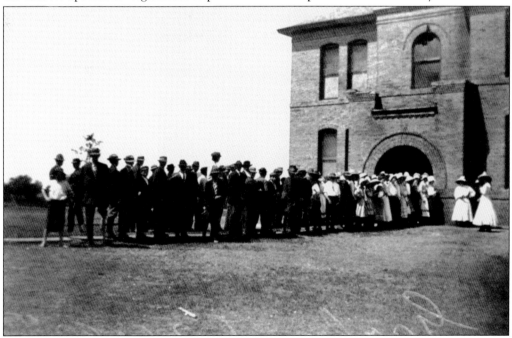

When Garland High School began utilizing the old Garland College building in 1901, it continued the practice of hosting civic events as well. This meeting of public citizens occurred in 1912. (Courtesy of Garland High School.)

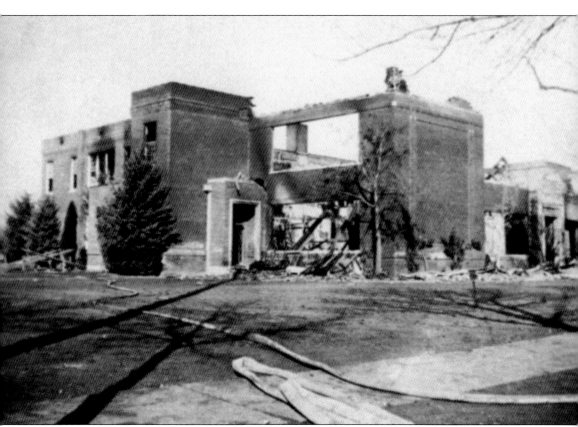

The old red schoolhouse was destroyed in January 1946. Elementary classes housed in the structure were generously covered in local churches and available structures until the current elementary school on Ninth Street was completed.

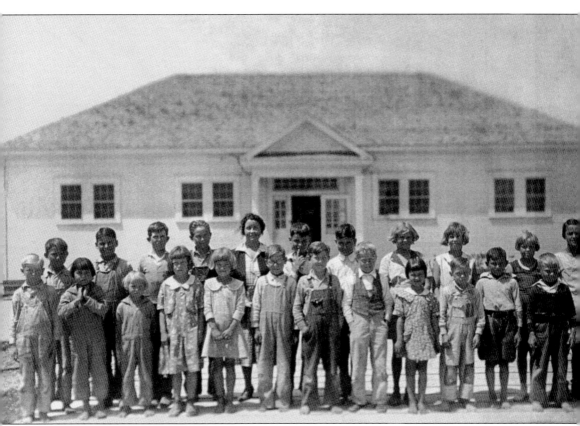

This image depicts the class of 1930 at Handley School, which served elementary-aged children. It was located on Jupiter Road west of where Raytheon sits today. At the time, it operated under the Dallas County school system. Later, it merged with Garland Schools, and the building became a part of the Garland High School. (Courtesy of Garland High School.)

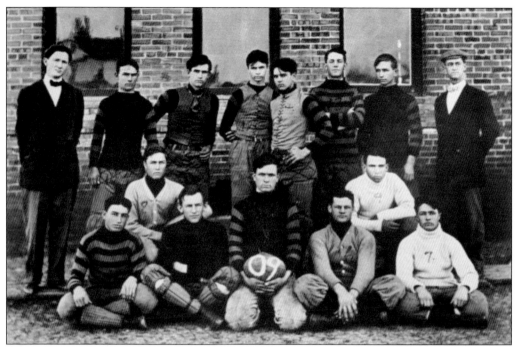

The fourth year of varsity football for Garland High School was in 1909. In these days of "leather necking," the team may or may not have been helmeted. The 1909 season results were one win, two ties, and three losses. (Courtesy of Garland High School.)

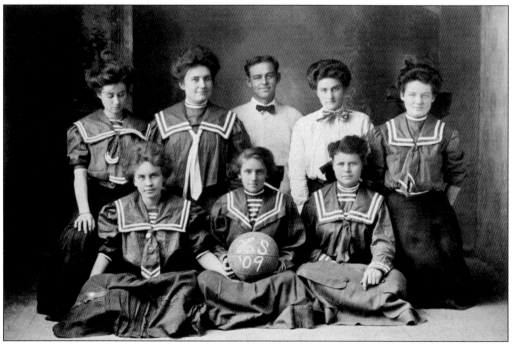

Basketball was a popular outdoor sport for young girls. Certainly, it was a fashionable operation. There was most likely a dirt court outside for matches with other high school students in the area. (Courtesy of Garland High School.)

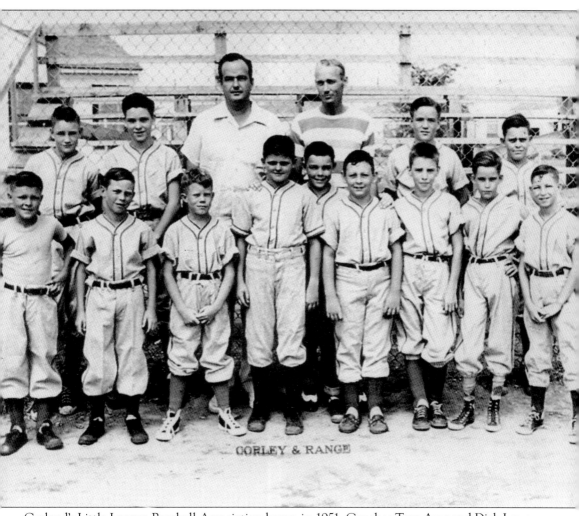

Garland's Little League Baseball Association began in 1951. Coaches Tom Aver and Dick Lowe trained their young cohorts at a field located near B.H. Freeman School. Today, Garland boasts a statewide reputation for its sponsorship of softball playoffs at its South Garland facilities on Oats Drive.

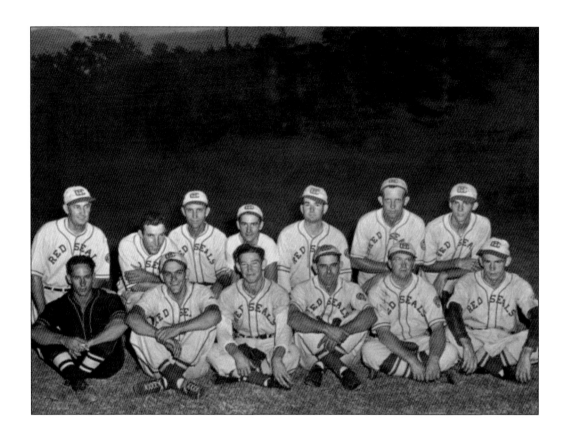

Even during World War II, local manufacturing companies (such as Continental Motors) would sponsor adult, nonprofessional baseball teams.

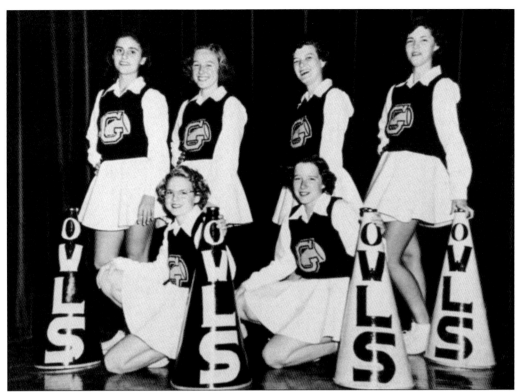

These Garland High School cheerleaders are happy about their winning season in 1951. They are, from left to right, (kneeling) Louise Turner and Joan Eggleston; (standing) Virginia Lewis, Jerry Burch, JoAnn Wyrick, and Virginia Hurt.

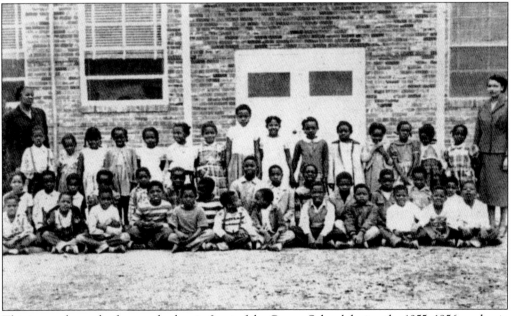

This image shows the first-grade class in front of the Carver School during the 1955–1956 academic year. (Courtesy of Carver Alumni Association.)

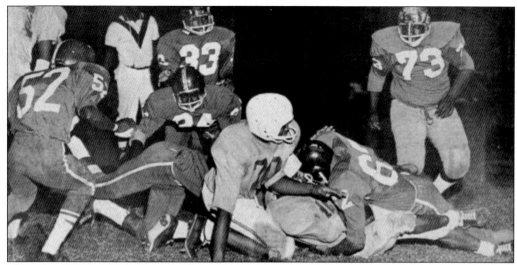

The Carver Tiger football team of 1964–1965 was connected with Class A of the Prairie View League. They made it to the finals, but lost to Bartlett. (Courtesy the Carver Alumni Association's Carver History Project.)

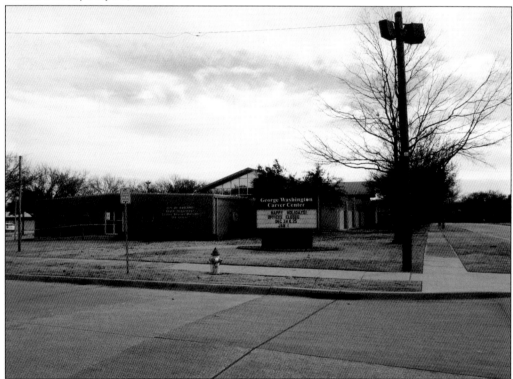

George Washington Carver High School for African Americans was opened in 1948 at 222 Carver Street. The school taught all Garland African American children grades 1 through 12 for 20 years until 1968, when desegregation began to change concepts and policies. The last senior class graduated in 1966, but grades one through eight remained until 1972. Today, the center is a multiuse building for the city and county. Members of the Carver Alumni Association still keep the memories and spirit of the old Carver School alive to this day.

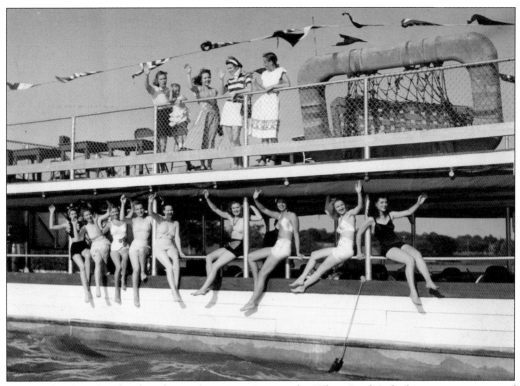

The Garland High School students of 1946–1947 enjoy the White Rock Lake boating operations of Garland entrepreneur Josh H. Williams Sr. His boating operation lasted from 1946 until 1956.

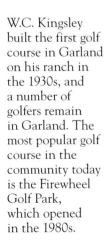

W.C. Kingsley built the first golf course in Garland on his ranch in the 1930s, and a number of golfers remain in Garland. The most popular golf course in the community today is the Firewheel Golf Park, which opened in the 1980s.

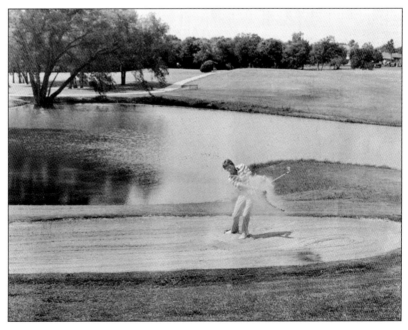

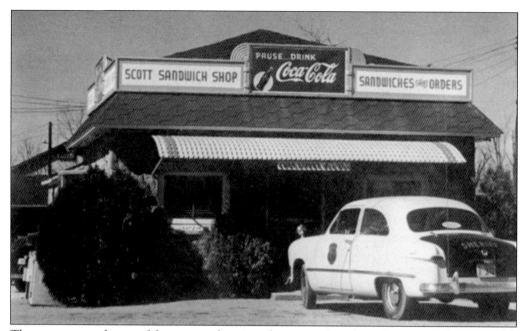

The ever-present throng of shoppers and cruisers downtown found satisfying nourishment in old-time coffee shops such as Scott Sandwich Shop and Nick's Café in the 1940s and 1950s.

Nick's Café was a popular greasy spoon from 1935 until 1954. Located near the Duck Creek Shopping Village, it was plagued with occasional grease fires. The 1954 fire was its last.

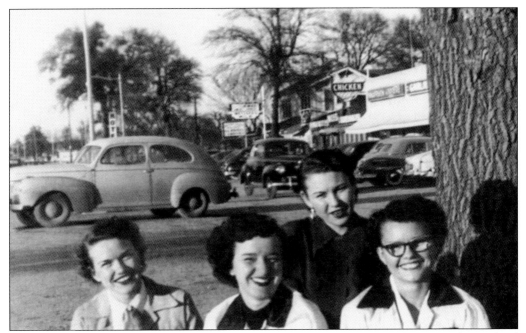

In the early 1950s, the Duck Creek Shopping Village remained a popular place near the Garland High School campus. It spread across Garland Road, Avenue C, and Avenue D and encompassed a number of local businesses, including Moore's Dining Hall.

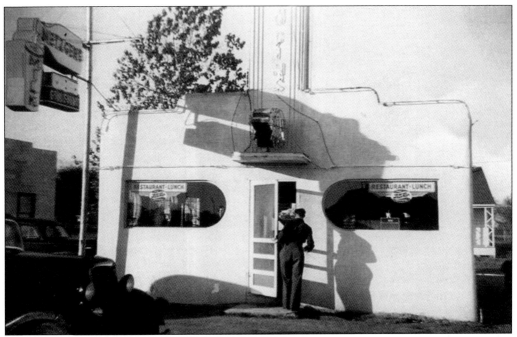

Known for "Garland's Finest Foods," Scoggins Café opened in the mid-1940s on Main Street (then the Bankhead Highway) near First and Third Streets.

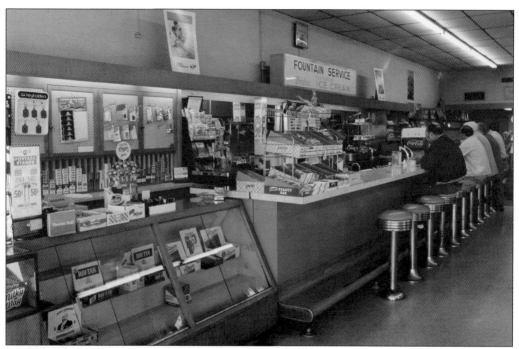

A favorite and much-missed business was the fountain service at the Orchard Hills Pharmacy. It sat across from the post office on Kingsley and Saturn Roads and was a tradition the Ridgewood neighborhood shared through the 1980s.

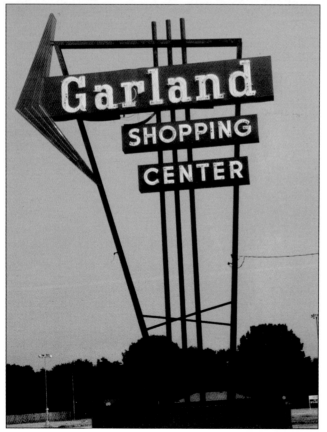

The first suburban mall in Garland was the old Garland Shopping Center anchored by Skillern Drugs in 1951 at the northwest corner of Miller and Garland Roads.

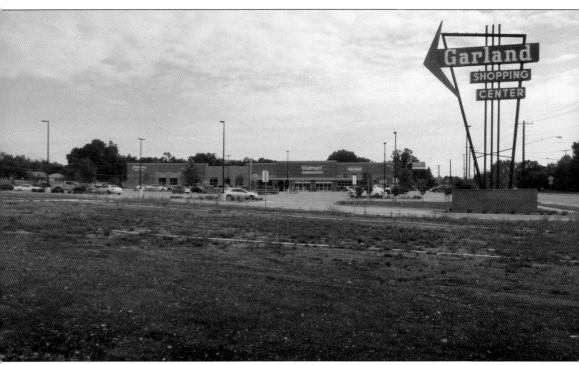

In 2014, the original Garland Shopping Center was upgraded, along with new shops anchored by a Walmart Neighborhood Market store.

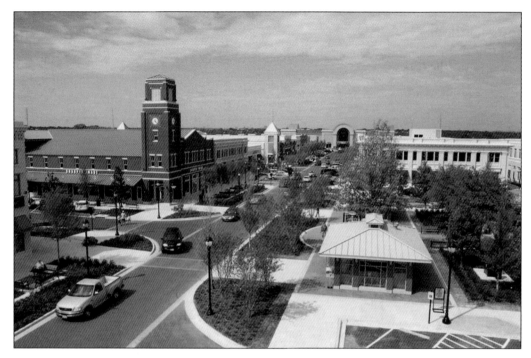

The Firewheel Town Center opened in October 2005 as a 1,004,000-square-foot, open-air, regional shopping mall. It sits at the northeast intersection of Highway 78 and the President George Bush Freeway on the northeast side of Garland. The mall's retro style of the downtown shopping experience of earlier generations, with a variety of retail shops and entertainment, is wildly popular for economic and social purposes among young and old alike.

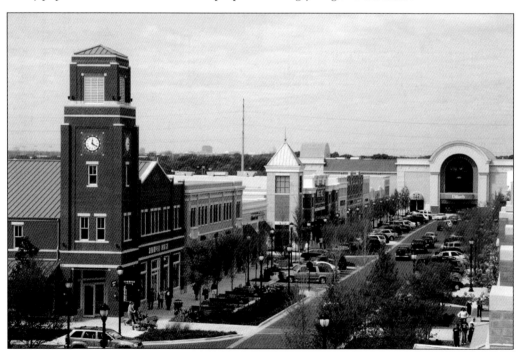

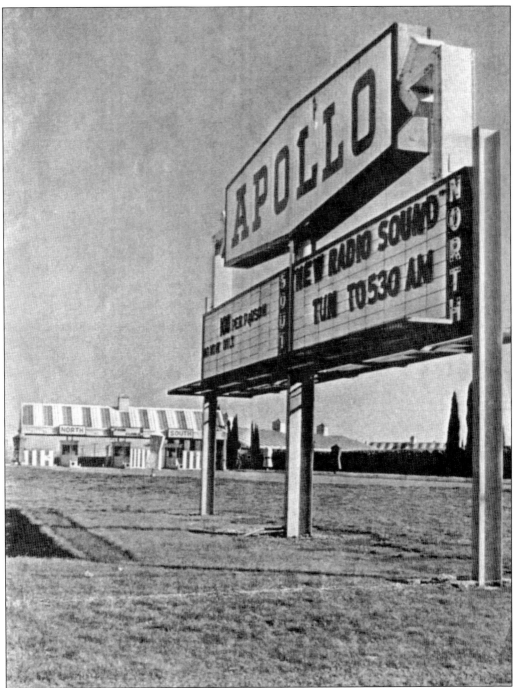

Any Garland baby boomer remembers the Apollo Twin Drive-in that was once part of the Gordon McLendon chain. It opened on April 7, 1950, as part of the Leon Theaters circuit of G.D. Leon. In the midst of a drive-in boom, two other Dallas drive-ins premiered openings in the same week. The location at Shiloh and Garland Roads could hold 1,800 cars. The Apollo thrived until the 1980s. By 1986, the property was cleared for the Walmart–Tom Thumb Hypermart, which was Walmart's prototype of the "supercenters" they now build throughout the United States.

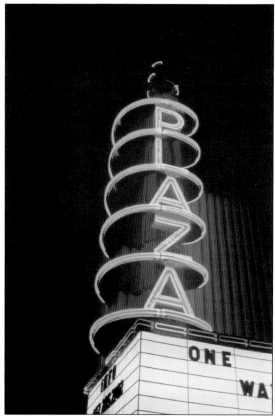

The original Art Deco–style Plaza Theatre opened in downtown Garland on April 4, 1941. It was not the first theater on the square, but it is the last remaining. Donated to the city in 1991, it now functions as a venue for a variety of live performances.

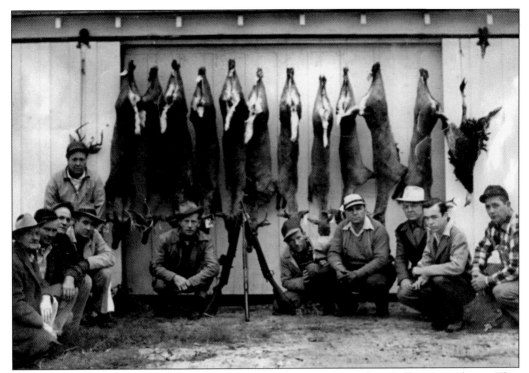

The Williams clan traditionally hosted hunting expeditions on their hill-country lease. This prosperous hunt was one of several in the 1950s and 1960s.

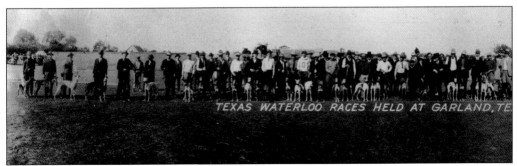

The 1923 Texas Waterloo Hunting exposition created quite a draw for hunting enthusiasts to come to Garland.

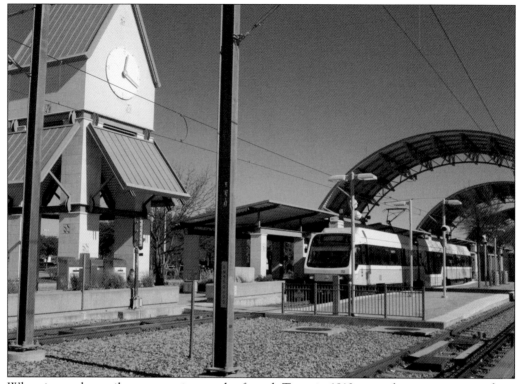

When interurban rails were crossing much of north Texas in 1913, an early attempt was made to secure a connection between Dallas and Greenville through Garland. A promoter named Crotty convinced local landowners to invest in the railway. Contractors were employed and began to clear right-of-ways; however, upon full funding of the project, work was not paid, and Crotty disappeared. The connection of DART (Dallas Area Rapid Transit) has had a considerable impact on the area's economy and future. One could only wonder how much impact the earlier tractor rail could have had on Garland's development.

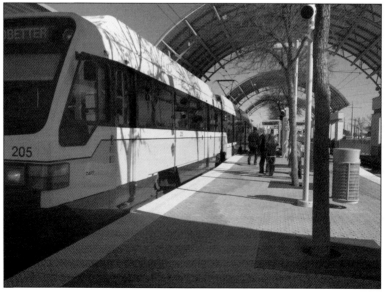

Five

Preserving Our Past, Finding Our Future

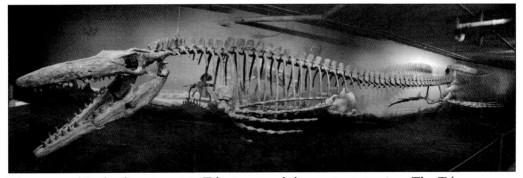

The genus of Garland's mosasaur is *Tylosaurus*, and the species is *prorigea*. The *Tylosaurus* was among the largest and most vicious of all the mosasaurs, reaching a maximum 40 feet and weighing approximately eight tons.

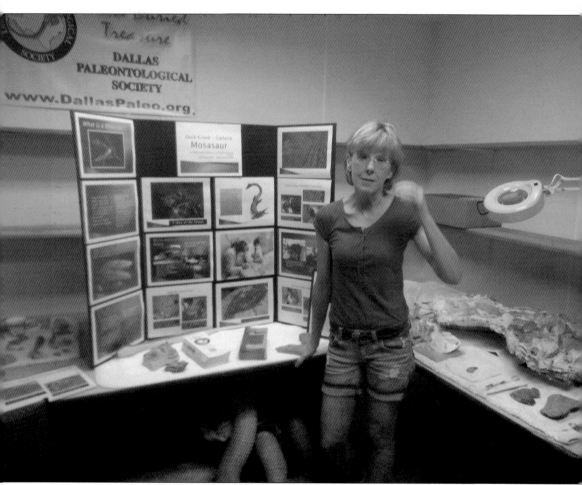

Led by Darlene Summerfelt, the volunteers of the Dallas Paleontological Society spent thousands of hours recovering the bones of Duck Creek's mosasaur, nicknamed "Mosie" by the society. The public display begins in the fall of 2014 at the Heard Museum in McKinney.

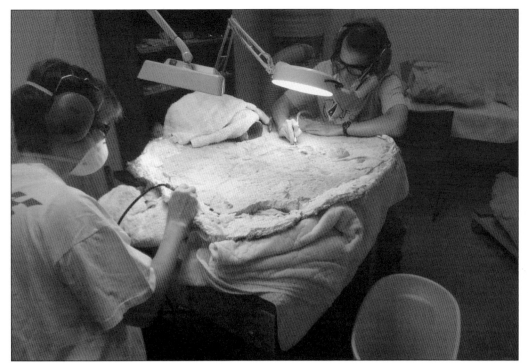
The time-consuming project required countless hours of carefully removing bones that have been encrusted in rock to prevent their disintegration.

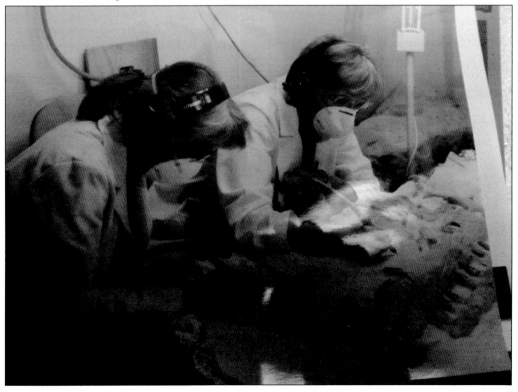

101

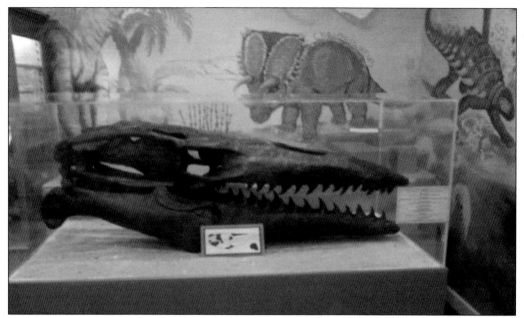

The tylosaur is already on display at the Heard Natural History Museum in McKinney. This amazing creature was found at Clear Lake Park at the edge of Lake Lavon.

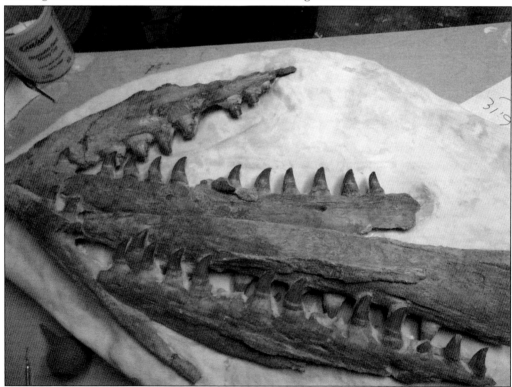

The unique jaws and bone structure made Mosie a ferocious creature of the sea. The mosasaur was able to lock its victim in its jaw while simultaneously devouring the same in a motion similar to a conveyor belt.

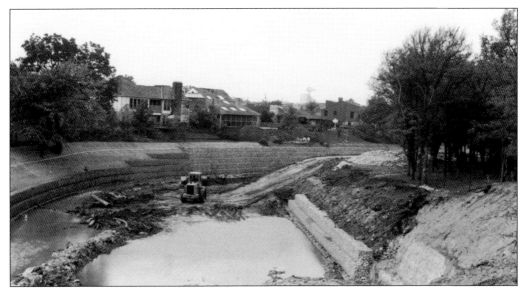

Mostly considered benign today, Duck Creek has caused its share of memorable deluges and destruction in its past. Old-timers might recall the horrendous Monday-night flood of June 13, 1949, when five people died. The most recent flooding occurred in 1990 and 1991, exactly one year apart. Subsequent city development and widening have reduced the likelihood of future disasters. The creek flows some 19 miles from Richardson southeasterly, merging with the East Fork of the Trinity in Kaufman County. Aside from the Lake Garland park venture of 1907–1939, city parks now envelop Duck Creek from Centerville Road to Oates Drive.

Since the floods of 1900–1991, Duck Creek has been generally "tamed" from its former infrequent and unpredictable floods.

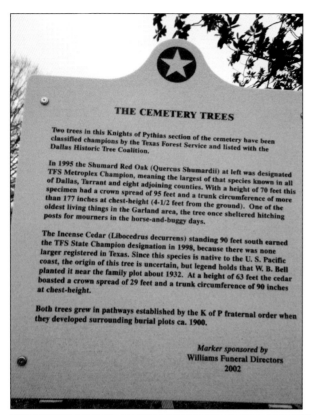

This plaque serves as a Garland historical marker.

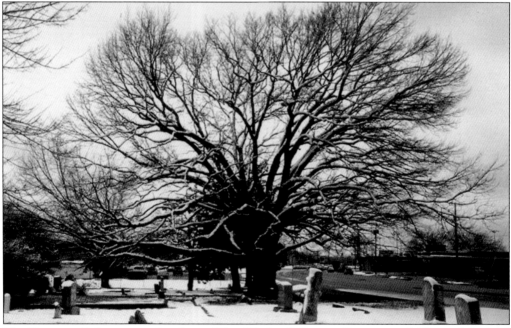

The Cemetery Oak once stood in the middle of Garland's Pioneer Cemetery at Miller and Garland Roads. Believed to be between 150 and 200 years old, it had witnessed many pioneer funerals. A lightning strike decimated the oak a few years ago.

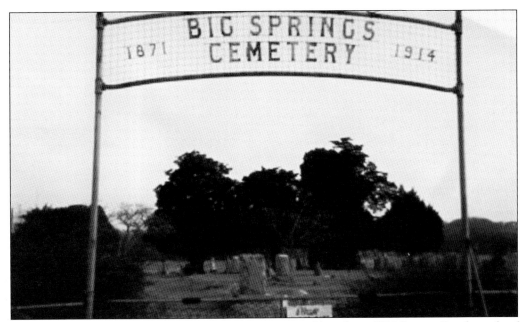

Big Springs Cemetery next to the Big Springs Baptist Church at 6538 Jupiter Road north of Campbell Road is all that testifies to that once-rural community.

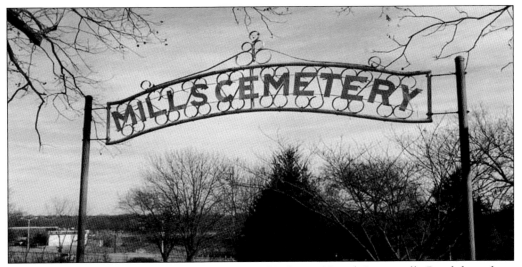

Mills Cemetery at 1925 Commerce Street near Highway 66 and Centerville Road dates from the 1850s. It was on the northeast corner of the land grant obtained by Ed Mills from the Peter's Colony.

This obscure cemetery named Fletcher Cemetery from the 1850s holds an estimated 100 pioneer settlers on the west bank of Duck Creek. Stripped of its headstones, it lies in the residential neighborhood of Orchard Hills off Glenbrook and Old Orchard Roads along a grassy alleyway.

This small plaque commemorates those who have markers in this cemetery, especially members of the Fletcher family.

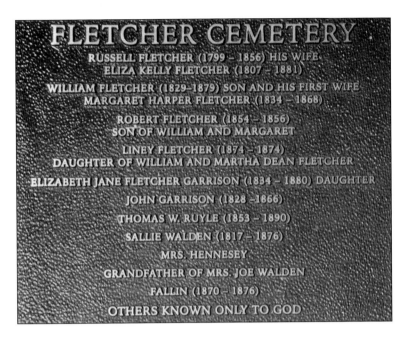

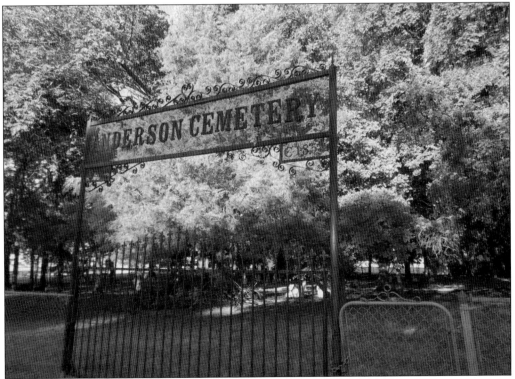

Anderson and Lyons Cemeteries both date to local settlements in the Rose Hill area from the 1850s. The Anderson Cemetery by the marina was once shadowed by the Anderson Cabin that stood from 1850 to 1930 next to it.

Lyons Cemetery sits on Barnes Bridge Road just west of Collins Road and about a mile from Lake Ray Hubbard. The road and the Barnes Ferry that crossed the Elm Fork of the Trinity River was the site of the old Republic of Texas National Highway.

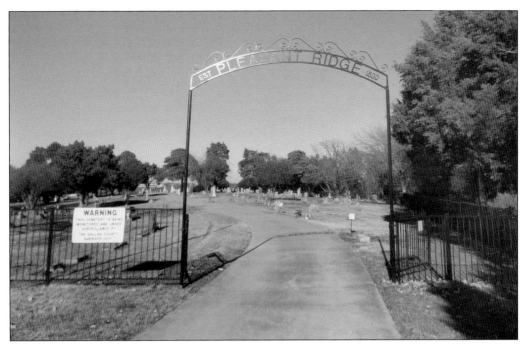

Pleasant Ridge Cemetery at Beltline Road near Barnes Bridge is now in Mesquite city limits. It contains many pioneers that settled the Rose Hill and Bobtown communities, which had many ties with Garland.

Myers Cemetery sits obscurely in the open. Situated in the parking lot behind the Shell station at Bobtown Road and Interstate 30, it is surrounded by walls. Some graves may be under the parking lot; nonetheless, it is marked and protects the Myers and Loving families.

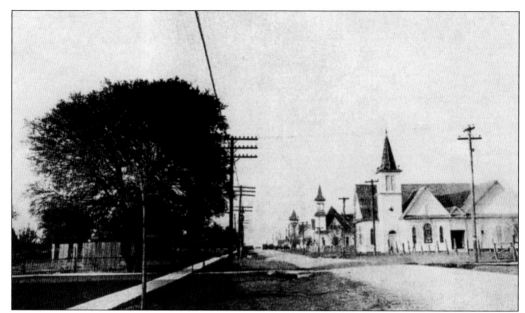

The community church services that commenced in the one-room schoolhouse of old Duck Creek birthed three churches. The Methodists began in 1852 and built their first church in 1871 south of the Masonic Cemetery. The First Baptist congregation (originally called the Antioch Church) organized in 1868 and built their first church in 1871 near Garland Road and Resistol Street. The Christian Church, organized in 1875, built their first church on Kingsley and Shiloh Roads in 1886. The close proximity of churches served as a bulwark for each. They shared in services over the years and worked to strengthen the community, which has prospered with a godly foundation.

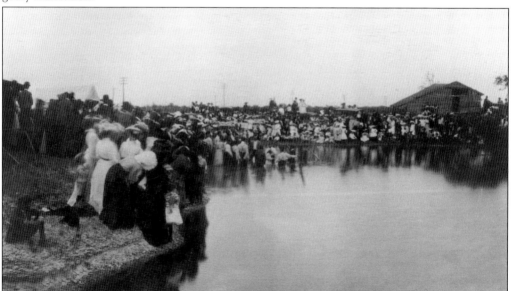

In the third year of evangelist Mordecai F. Ham's ministry, he preached a two-week revival in Garland that "shook the town." The subsequent baptism service at the Tinsley farm was well attended. His first year of revivals produced 33,000 converts. Spanning a lifetime of ministry, he had over 300,000 converts, including Billy Graham in 1934.

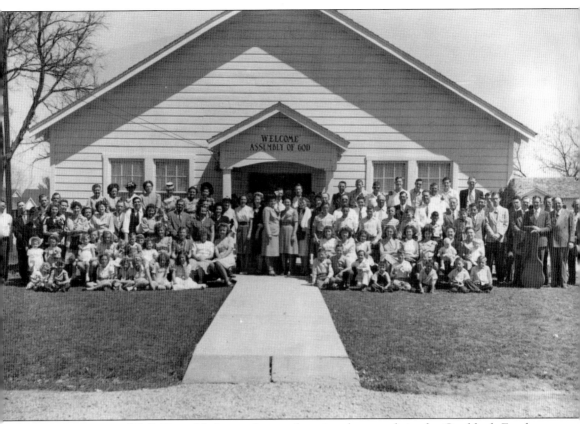

In 1938, a group of Full Gospel believers began devotionals at work in the Craddock Foods Company. That was the pickle plant that once stood on Walnut Street where the Central Post Office sits today. On Friday nights, they began all-night prayer meetings. Within a year, their fellowships in the Pentecostal Pickle Prayer meetings led to the creation of the First Assembly of God Church. Their first church began in 1938 at Third and State Streets. The church then moved to Buckingham, Texas, as First Assembly of God in Garland and is now known as First at Firewheel at 5500 Lavon Drive, which has recently celebrated its 75th anniversary.

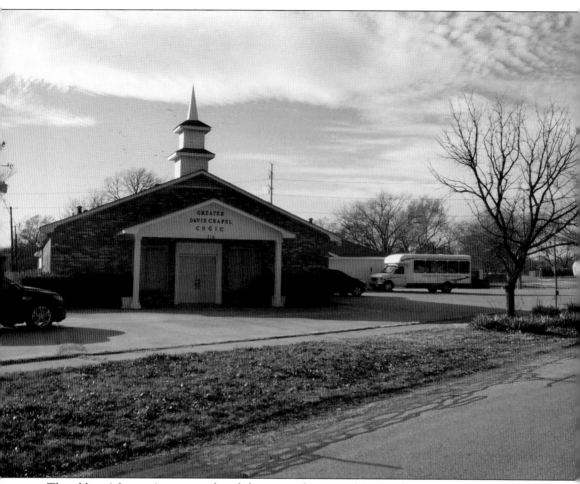

The oldest African American church began in the area of Garland Road–Forest Lane on Duck Creek. The Greater Davis Chapel Church of God in Christ (pictured) began in 1916.

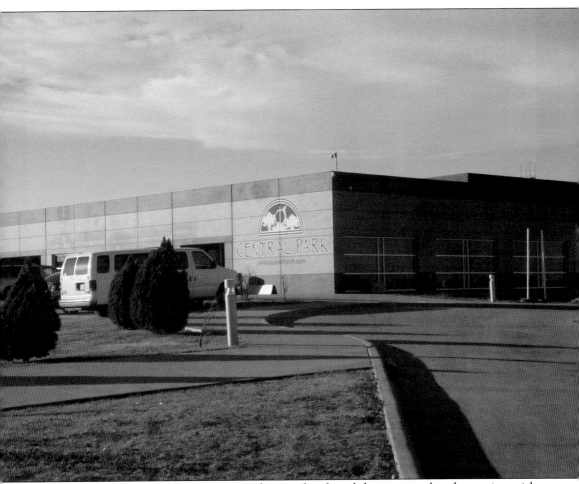
The Central Park Iglesia de Dios is a good example of a solid-structure church growing with the community.

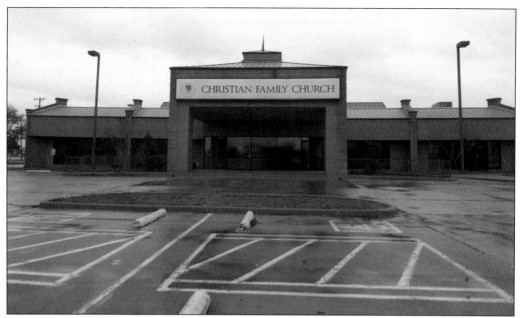

Among the newest congregations in Garland is the Family Christian Family Church at Broadway and Centerville Roads. It began as the Winners Edge Church with Pastors David and Linda Albritton. Upon Brother David's passing, the church joined the Christian Family Church fellowship. The growing congregation today is pastored by Rick and Julie Carter.

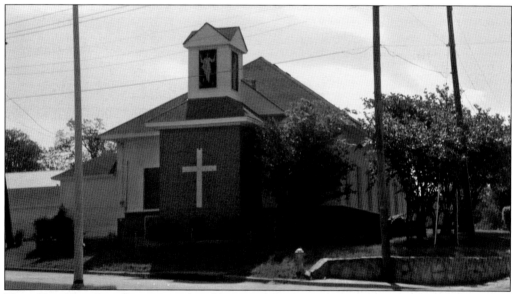

The oldest church still in use is the old Rose Hill Christian Church at 1002 Rowlett Road. The congregation eventually moved to 3307 Bobtown Road as the Lakeview Christian Church. The building, constructed in 1913, reportedly had a Bible laid in part of the foundation to symbolize the church's doctrinal beliefs. Currently, the structure is occupied by the Bethany Lighthouse Church.

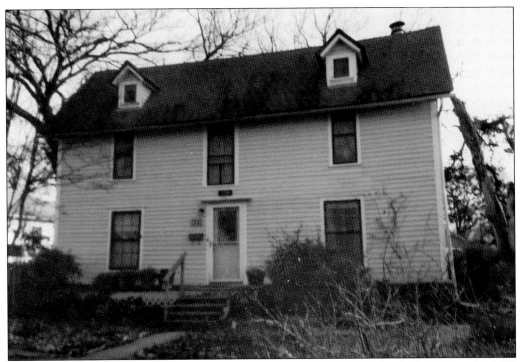

This house on 820 Avenue E is owned by Ray Markell and was on the land of G.W. Routh's 1855 homestead. It remains among the oldest homes in Garland.

Allegedly built in 1889 in Embree, the old Ryon House at 301 South Ninth Street is currently being restored by Charles and Amy Thibodeaux. Dr. John Ryon owned the house before its purchase by the Sibley family, who occupied it until 1953. It was later purchased by Emma Newton, and in later years it served variously as a restaurant and an antiques/art center.

Built in 1888, this house was bought by the Coyle family in 1890. It was occupied by some members of the family until 2005, setting a record in Garland for the longest occupancy of one family in a home (115 years). (Both courtesy of Carlos and Jennifer Acosta.)

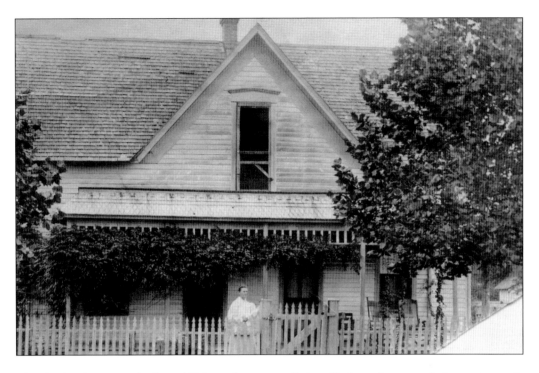

The Coyle House was built in 1888 in what was still then Embree. It is seen below as it stands today at 915 Avenue E. (Both courtesy of Carlos and Jennifer Acosta.)

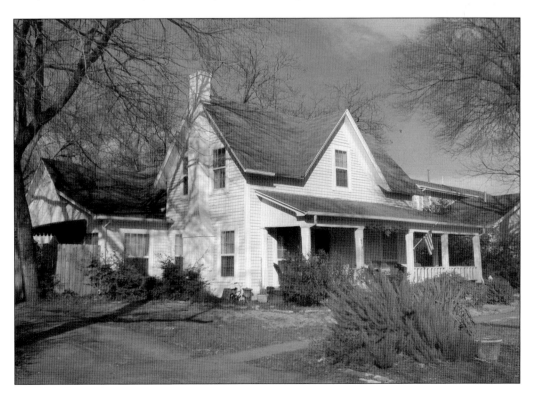

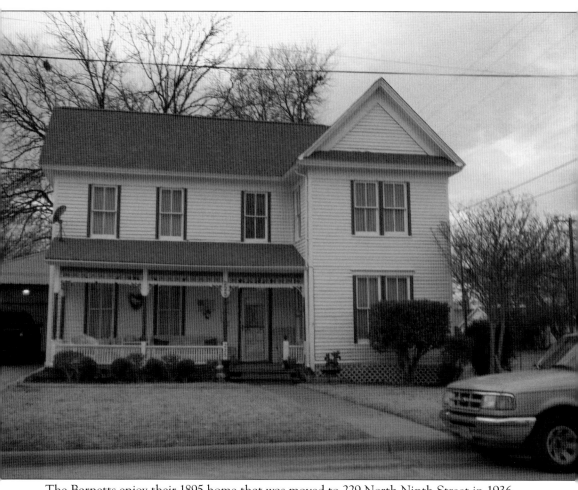
The Barnetts enjoy their 1895 home that was moved to 229 North Ninth Street in 1936.

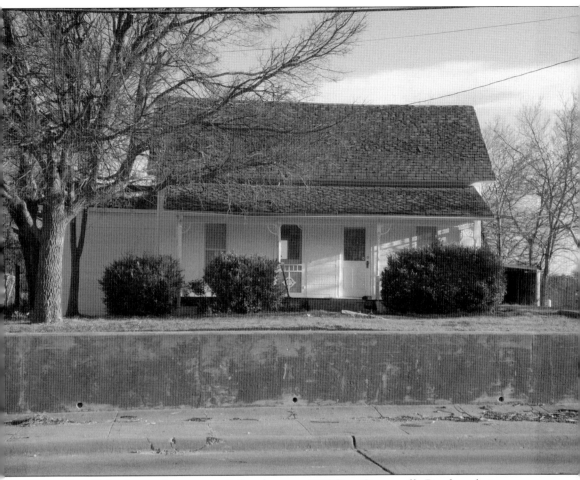
This is the old Anderson sharecropper's farmhouse at 1018 East Centerville Road on their cotton farm. The house was built by Ben Maxey in 1902, and the Anderson family lived there until 1940. It was finally sold out of the family sometime between 1980 and 1982. It still stands just east of Broadway. (Courtesy of the Richetti family.)

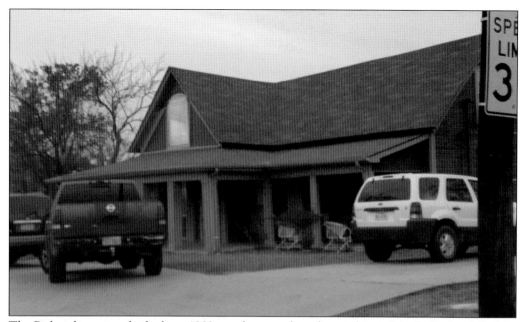

The Pickett house was built about 1903 on what was then the outskirts of south Garland. Pickett married one of the G.W. Routh daughters and was a brother to J.W. Pace. Currently, the Richetti family owns the home. (Courtesy of the Richetti family.)

The Eleventh Street area is home to many houses built in Garland's Travis College Hill addition, which was planned by the Interurban Land Company in 1913.

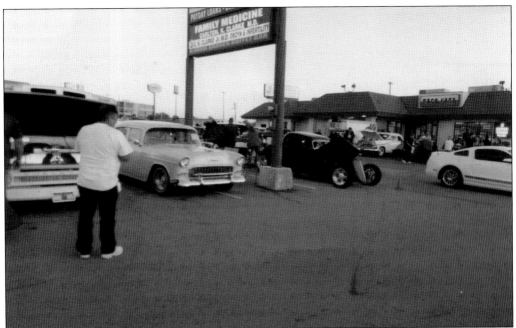

Vintage cars are still a passion among many in Garland, crossing age, gender, race, and social standing. Many folks in Garland will stop to take a quick trip of nostalgia any time a classic-car rally occurs on Broadway at Interstate 30 next to Taco Casa. The oldest vehicle in Garland is the 1903 Oldsmobile Runabout that Joe Hillhouse received from his grandfather, who bought it new.

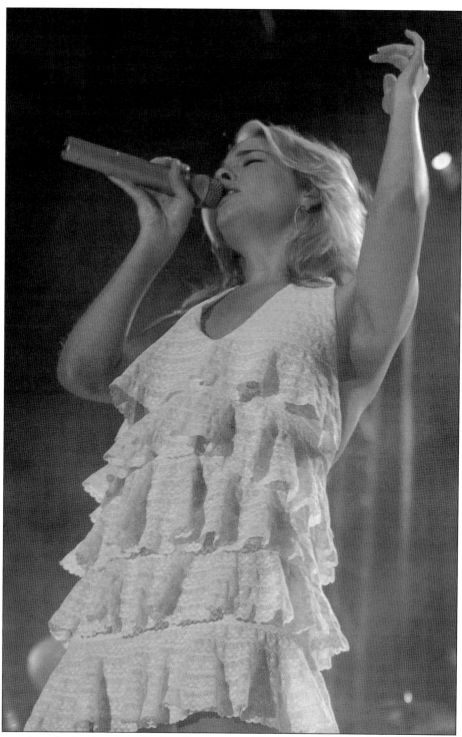

Grammy Award–winning singer LeAnn Rimes started her musical career in Garland. As a preteen, she sang at both the Garland Opry and the Wylie Opry. Her breakthrough album, *Blue*, at age 14, made her one of the youngest musical artists to win a Grammy.

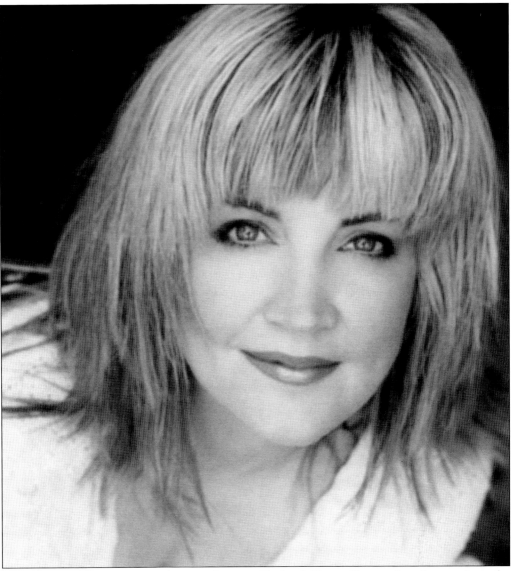
Crystal Bernard is a singer and actress born in Garland, Texas. She was best known from the television comedy *Wings* and the ever-popular *Happy Days*.

The Tinsley/Lyles house and the Pace house were donated to the Landmark Museum Park a number of years ago. Both represent the 19th-century residential architecture characteristic of the Garland area. Upon completion of the new Landmark Park, the houses were relocated.

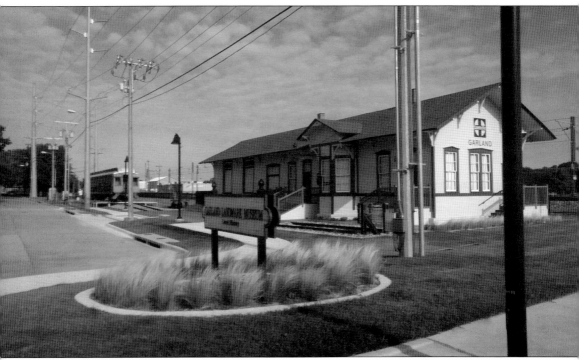

The Landmark Museum has come full circle to its new home beside the DART rail system. Upon its dedication on May 31, 2014, the new site behind the Nicholson Central Library now houses the restored depot and train carriage, as well as a host of local artifacts and historical records of the area. Its annual historical calendars are keepsakes for Garland history lovers.

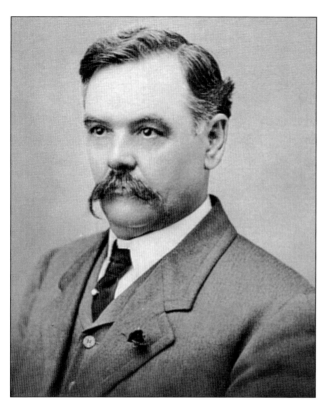

Originally a settler near the Embree and Duck Creek communities, Marion D. Williams eventually served as the first mayor of Garland.

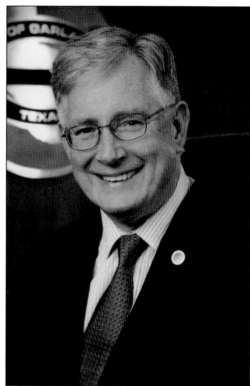

A seasoned council member and active Garland resident, Doug Athas was elected mayor in May 2013.

Mayors of Garland

Marion D. William: 1891–1893, 1931–1934
John A. Martin: 1897–1900
John H. Cullom: 1902–1903
E.G. Cole: 1906–1908
T.J. Swim: 1900–1901, 1903–1904, 1908–1910
John White: 1912–1913
R.L. Reagan: 1913
George A. Alexander: 1910–1912, 1918–1920
George W. Crossman: 1905, 1916–1917
R.D. Murphree: 1920–1924
S.E. Nicholson: 1924–1925
G.L. Davis: 1925–1927
C.S. Nelson: 1927–1929
W.C. Jamison 1929–1931, 1934–1936
J.A. Alexander: 1936–1939
Ray Olinger: 1939–1948
D. Cecil Williams: 1948–1952
H.A. "Bud" Walker: 1952–1956
W.H. Bradfield Sr.: 1956–1958
Ernest E. Wright Jr.: 1958–1962
Carl Cooper: 1962–1966
James Toler: 1966–1970
Rufus Rupard: 1970–1972
Don Raines: 1972–1976
Charles Clack: 1976–1982
Ruth Nicholson: 1982–1984, 1988–1990
Charles G. Matthews: 1984–1986
William Tomlinson: 1986–1988, 1990–1992
Bob Smith: 1992–1994
James Ratliff: 1994–1998
Jim Spence: 1998–2002
Bob Day: 2002–2007
Ron Jones: 2007–2013
Doug Athas: 2013–present

DISCOVER THOUSANDS OF LOCAL HISTORY BOOKS FEATURING MILLIONS OF VINTAGE IMAGES

Arcadia Publishing, the leading local history publisher in the United States, is committed to making history accessible and meaningful through publishing books that celebrate and preserve the heritage of America's people and places.

Find more books like this at
www.arcadiapublishing.com

Search for your hometown history, your old stomping grounds, and even your favorite sports team.

Consistent with our mission to preserve history on a local level, this book was printed in South Carolina on American-made paper and manufactured entirely in the United States. Products carrying the accredited Forest Stewardship Council (FSC) label are printed on 100 percent FSC-certified paper.